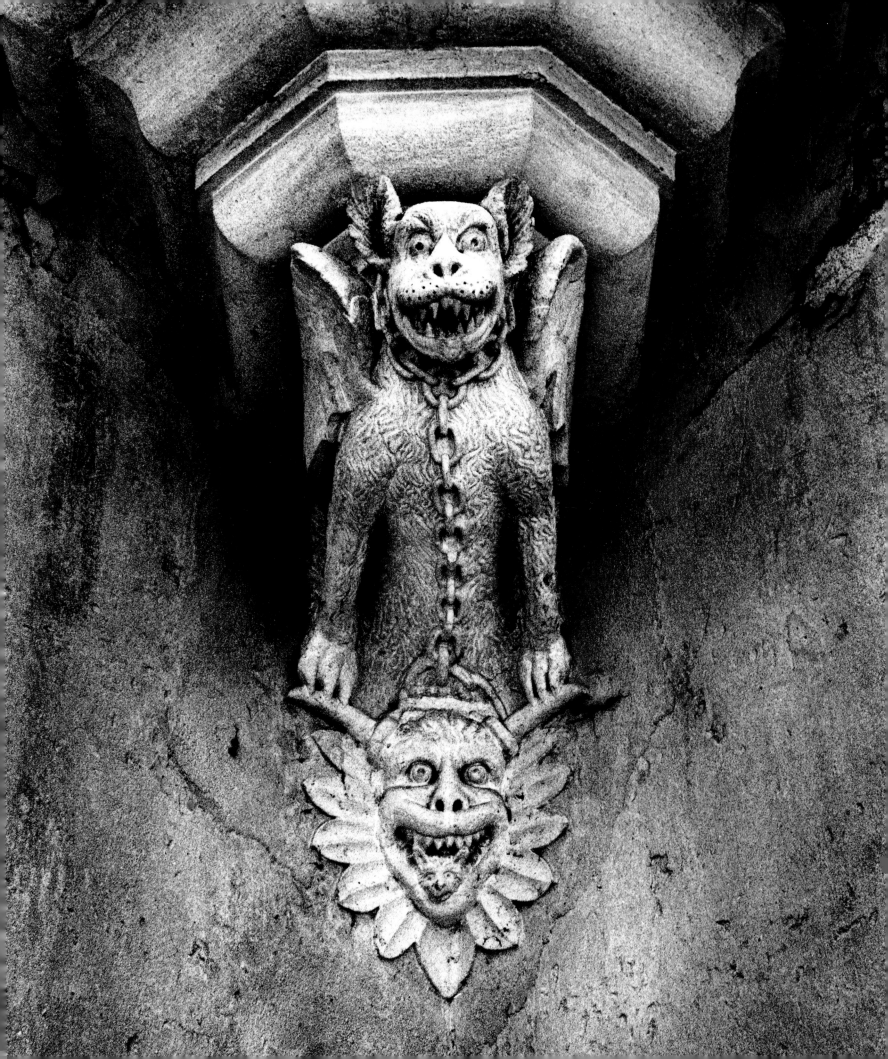

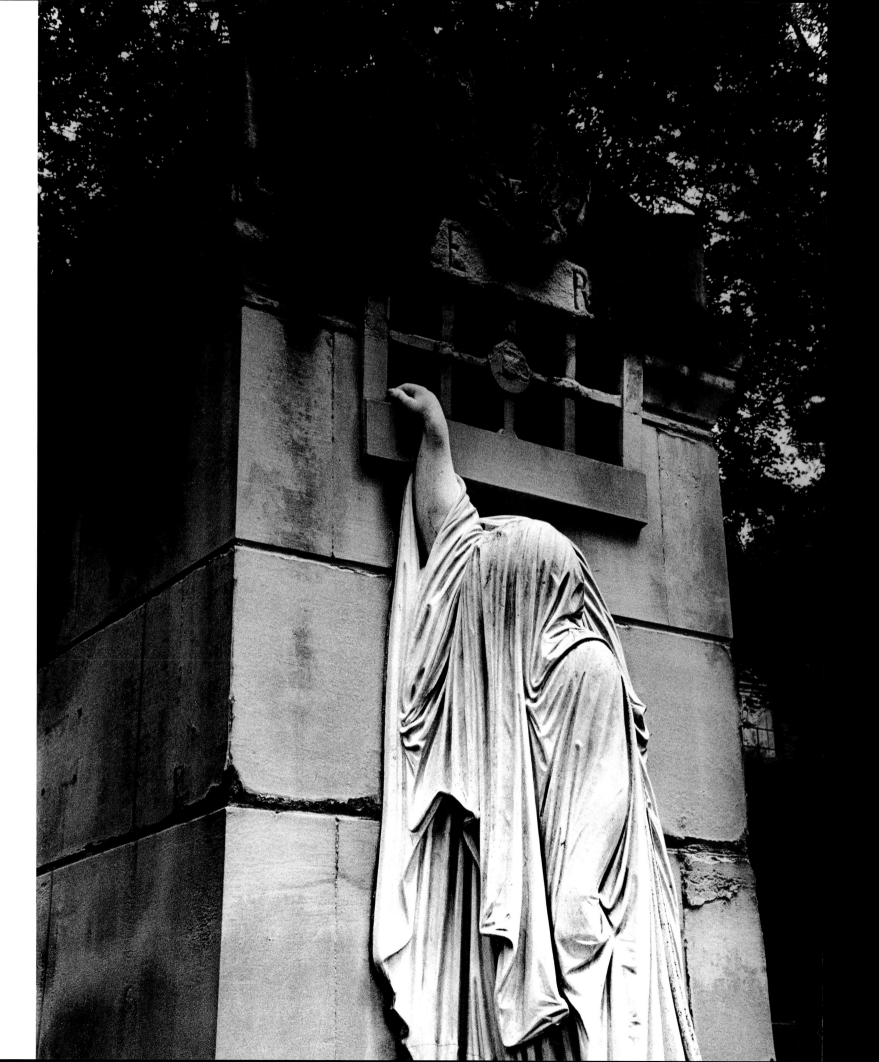

Startled by a scrawny black cat that crossed my path before disappearing into a shattered vault, I was forced to stop to consult my map. As I looked around to get my bearings, I was drawn to a particularly ornate mausoleum. In the shape of a cenotaph, it was adorned with owls and other dark creatures of the night. A curious relief, carved into the stone, depicted two symmetrical groups—one group representing the dead, and another representing the living—that appeared to be confronting one another and to be making way for a floating winged skeleton playing a trumpet (see pages 22–23). Just as I raised my camera to record this haunting scene, I heard a voice behind me say, 'He was a magician who liked to scare people to death.' The speaker was a short, portly man, who continued, 'His name was Etienne Gaspard Robertson, a Belgian. He invented "Phantasmagoria"—the use of lantern slides to produce horror shows.'

Curious to hear more, I let him continue. 'He was an optician, who developed a great interest in magic. His terrifying shows became very fashionable in the late eighteenth and the early part of the nineteenth centuries. He created a shifting scene of optical illusions, in which figures increased or decreased in size, faded away, and passed into each other. Many of the audience were fooled

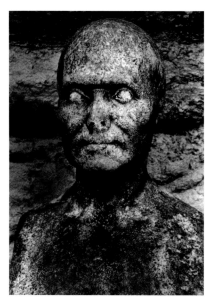

into thinking that these were the spirits of their departed loved ones.'

I asked him whether he himself believed in ghosts, and he smiled saying, 'Yes, I accept what my own eyes see, but I don't expect anyone to believe me.' Later he added, 'Walking here I sometimes feel too close to the dead and too far from the living to make a rational judgement on such things.' He said that he kept away if possible from the eastern corner of the cemetery, especially the Mur des Fédérés outer wall where, during the Paris Commune, 147 communards were shot at dawn on 28 May 1871, having fought their way across the graveyard the night before. They were buried against the wall where they fell, but their ghosts are still seen and heard by both staff and visitors. Some claim that there is a secret tunnel linking the cemetery with the Paris catacombs, and that black magic rituals have been held amongst the graves in the dead of night.

Failing light was drawing a veil over the graveyard and I was anxious to leave. This is without doubt a haunted place, where the dead may not always rest in peace. Bidding the man goodbye, I turned to go, knowing that the shadows of the night were gathering, and feeling that at this moment their path seemed far too close to mine for comfort.

above
Tomb detail, Père Lachaise Cemetery

facing page
Carving on Bourdeney family tomb, Père Lachaise Cemetery

pages 22–23
Detail on the tomb of Étienne-Gaspard Robertson (1763–1837), Père Lachaise Cemetery

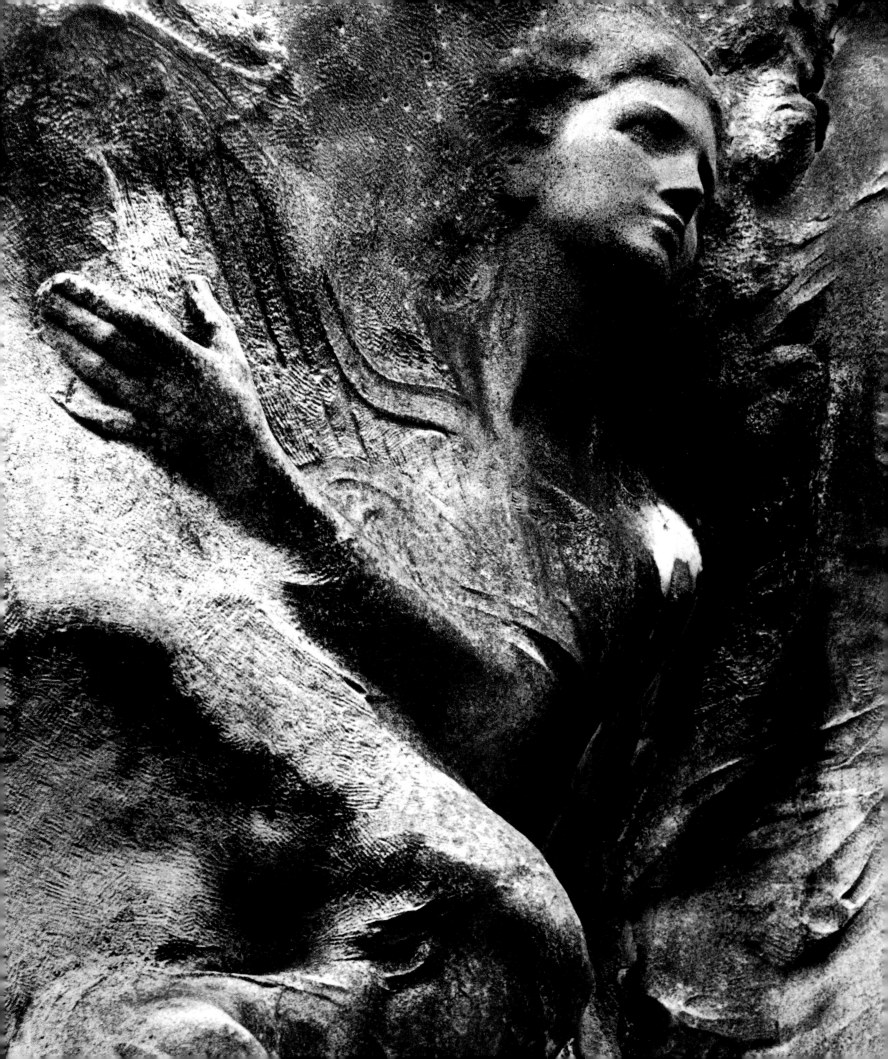

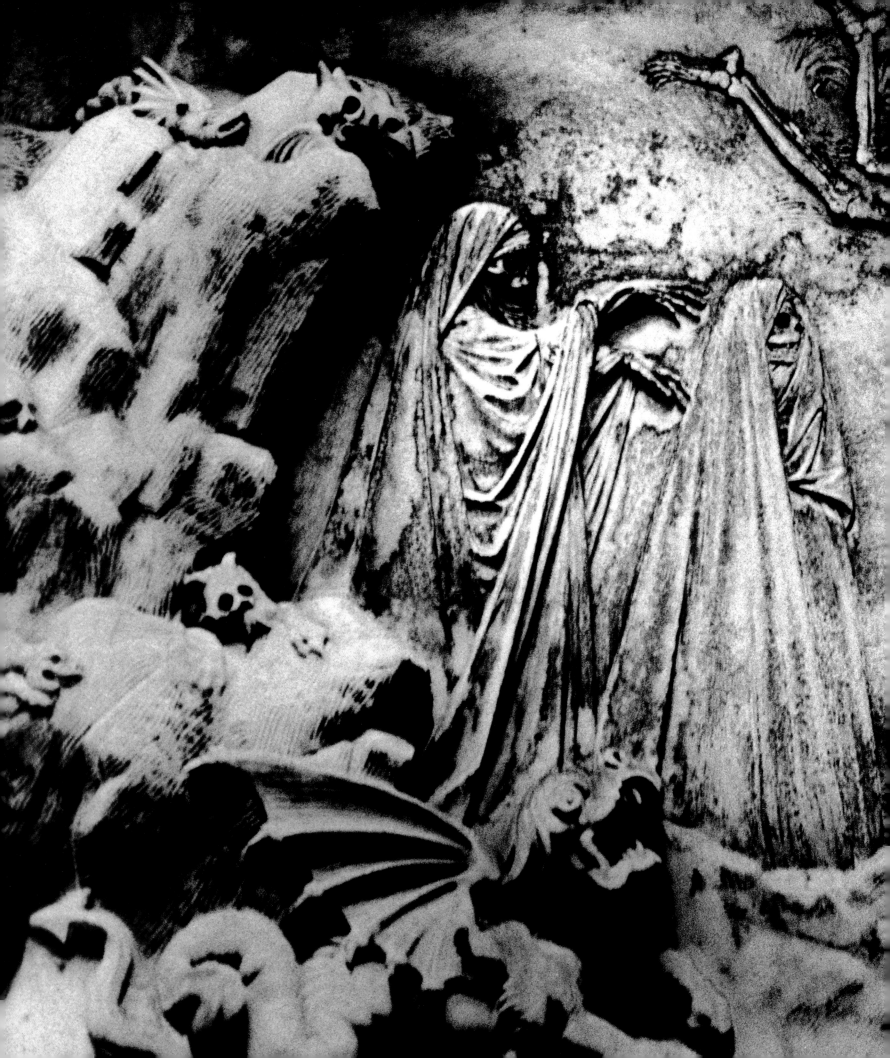

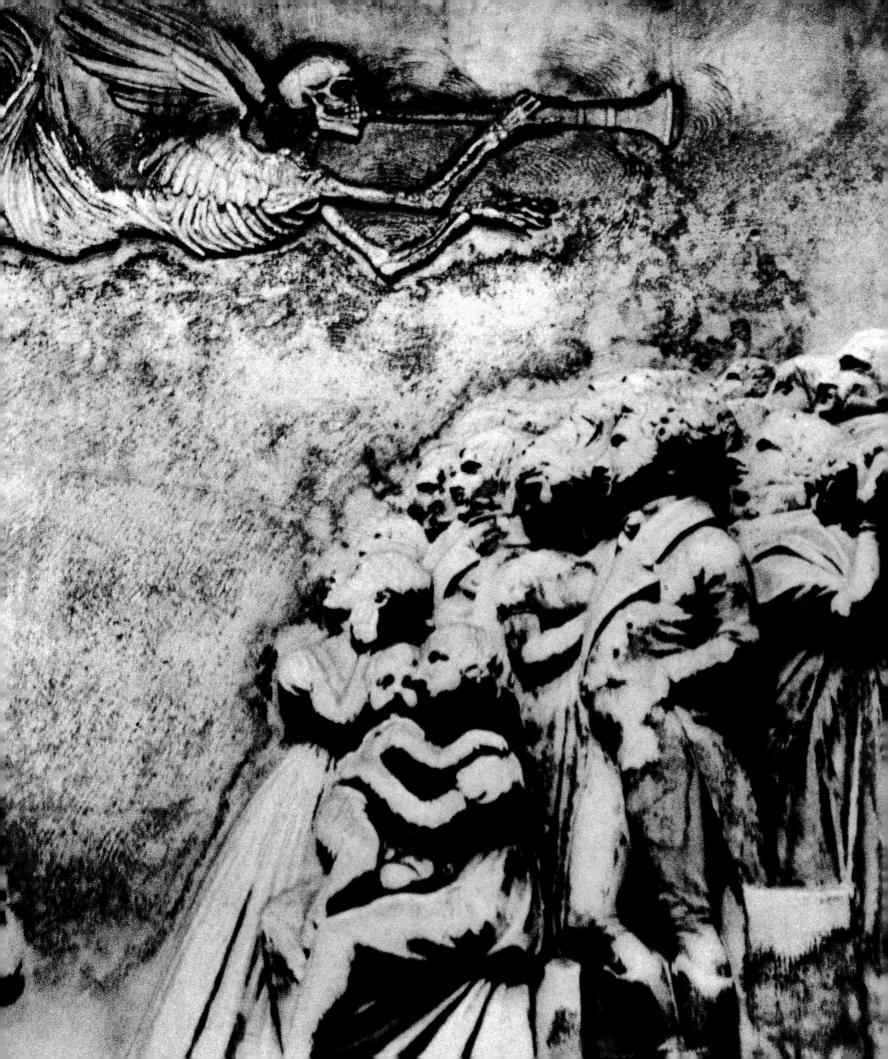

ÎLE-DE-FRANCE — CHÂTEAU VIEUX, SAINT-GERMAIN-EN-LAYE
Witchcraft and Sorcery
- 8 September -

The commune of Saint-Germain-en-Laye lies in the western suburbs of Paris. Prior to the Revolution in 1789, it was a royal town and the residence of French monarchs. The château was constructed in 1348 by King Charles V over the foundations of an older castle; it was redesigned in the sixteenth century. Louis XIV (1638–1715) was born in the town, which bears his coat of arms; he established his principal residence there from 1661 to 1681.

After Louis moved his court to Versailles in 1682, he handed over the château to the exiled King James II of England. Branded a coward by his former supporters, the Stuart monarch had fled from Ireland to France after his Catholic army had been defeated at the Battle of the Boyne in 1690. A broken man, he became an austere penitent during the final years of his life, dying of a brain tumour in 1701. I was told that his ghost has been seen in the château, but more often in the grounds. The tragic king's apparition is also seen at Athcarne Castle in Ireland, where he rested the night before his Jacobite army was defeated by the Protestant William of Orange.

But it is the period preceding Louis's move to Versailles that left its indelible mark on the château's history, a scandal that became known as the 'Affair of the Poisons'. In 1676 the Marquise de Brinvilliers, an aristocrat with a history of remarkable sexual depravity, was executed after confessing under torture to the poisoning of her father and two brothers. At least four hundred people, many

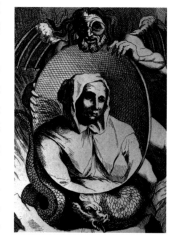

of them representatives of the noblest families in the country, were implicated in practices ranging from poisoning to sorcery. Louis XIV was shocked, blaming himself for allowing such evil to arise in his Court. Then, to his horror, one of his mistresses, Madame de Montespan (see pages 102–103) was acccused of engaging in satanic rituals and seeking to poison a rival for the king's affections.

All of Europe was focused on these investigations, which repeatedly led to Catherine Deshayes Monvoisin, a sorceress known as 'La Voisin' ('The Neighbour'). She was a midwife and fortune-teller of lowly birth, who arranged abortions and brewed 'love potions' and poisons for Parisian ladies, later dabbling in witchcraft and Satanism. Her corrupt associates included the magician Lesage, a practitioner of alchemy and the black arts. Human blood and human dust were among the ingredients of her love powders, and she also stood accused of providing babies for sacrifice. She had frequently visited the château at Saint-Germain, and Madame de Montespan was one of her clients.

The *Chambre Ardente* (Burning Court) was set up to judge witchcraft and poisoning cases. 'La Voisin' was tortured and, in February 1680, burnt alive in what is now Place de l'Hôtel de Ville in Paris. Curiously, a vast number of incriminating papers went missing during the investigations. Though undoubtedly guilty, the socially inferior 'La Voisin' had provided a perfect smokescreen for the aristocrats involved.

above
Portrait of Catherine Deshayes, known as 'La Voisin', anonymous, 1680

facing page
Steps to the terrace, Château Vieux

pages 26–27
Château Vieux

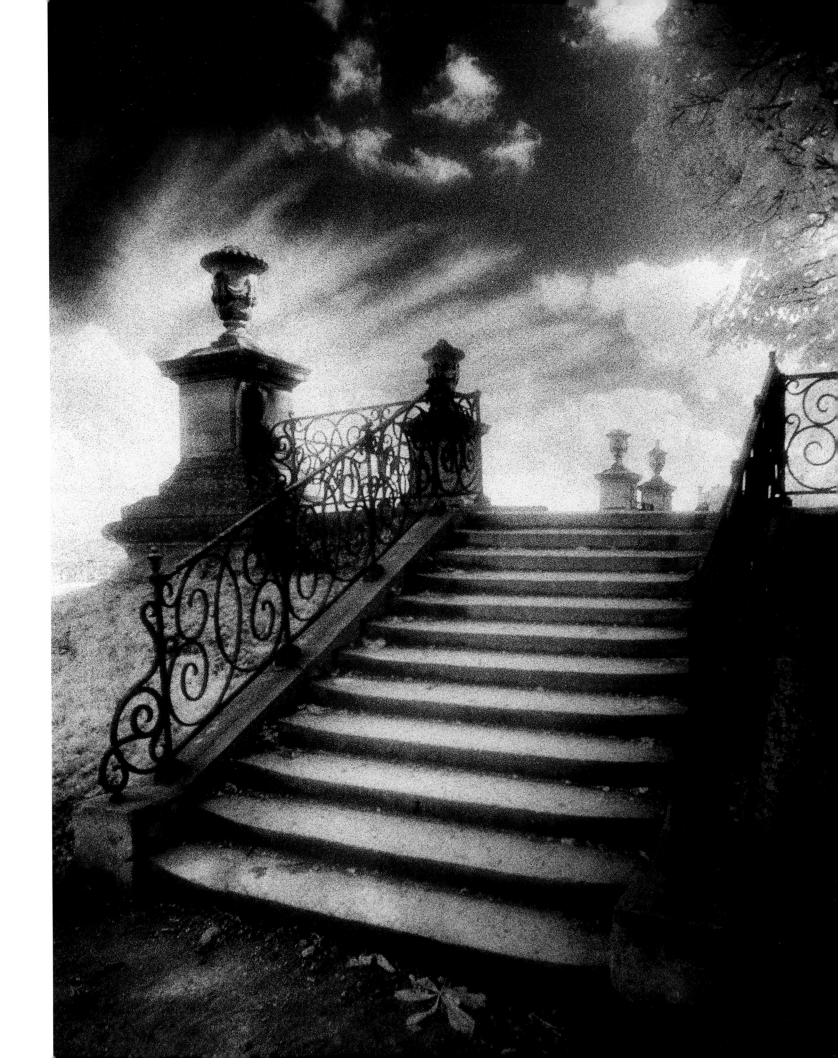

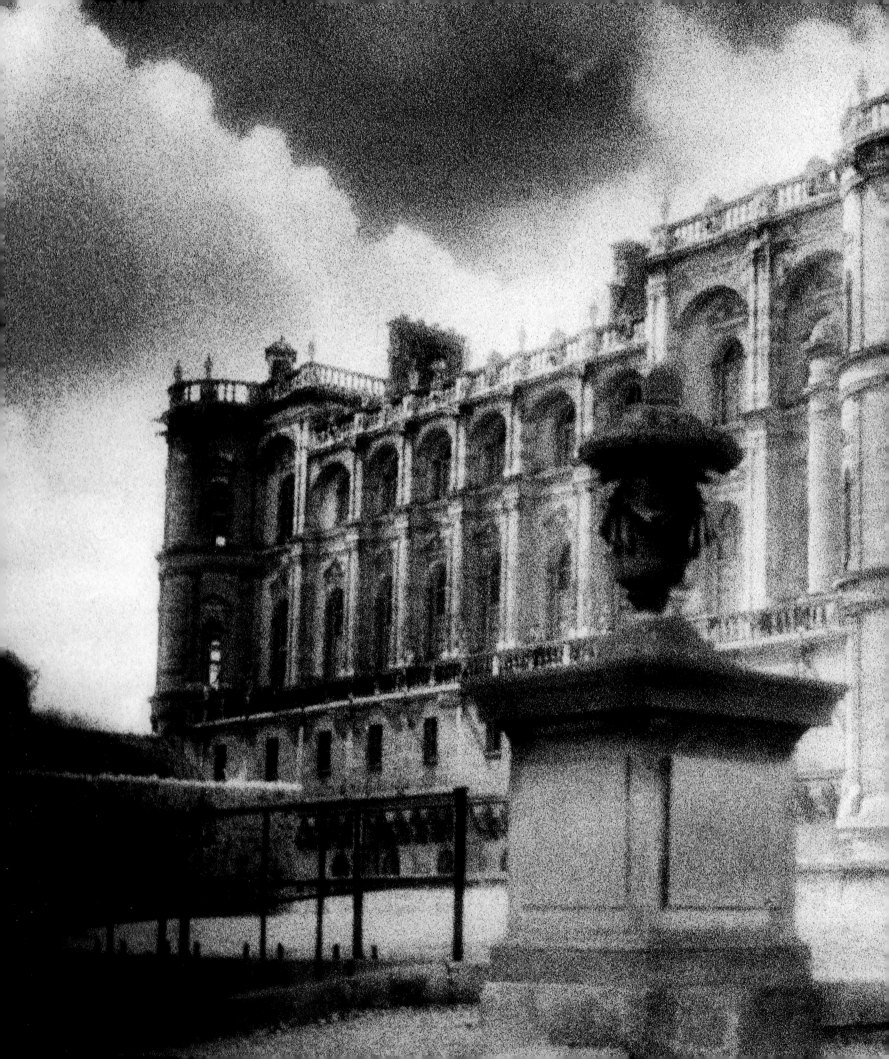

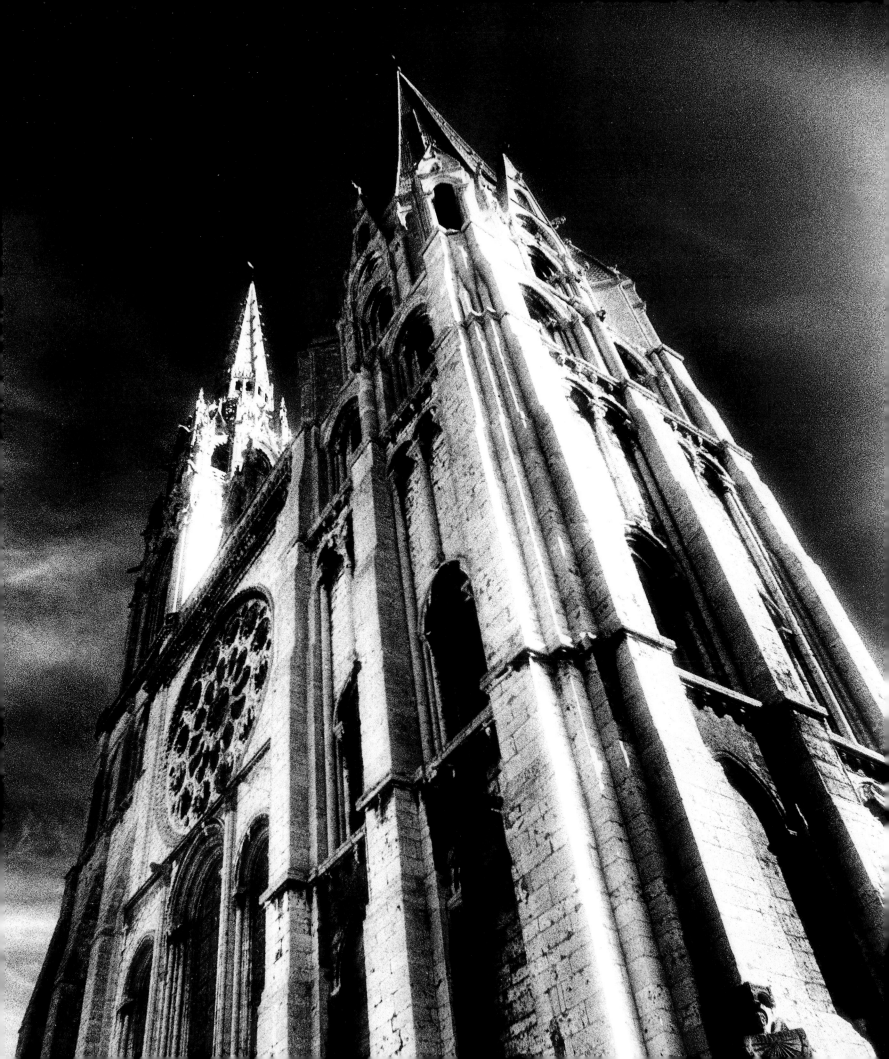

ÎLE-DE-FRANCE — DAMMARIE-LES-LYS ABBEY

The Lost Tomb
- 12 September -

As I was raised in the depths of the English countryside, I have never felt at ease in the city. Now I found myself in the industrial outskirts of Melun, a town to the southeast of Paris, and I was beginning to wonder if the abbey ruins could really be so close. Passing yet another derelict factory, I suddenly saw a sign for the priory and turned off the main road to stop next to what appeared to be a municipal park. As I got my cameras from the boot of the car, I realized I was being watched by a group of youths from the nearby flats, but as long as I had my equipment with me it was all right. Besides, the excitement of what I might find far outweighed the risk for me.

Finding a path into the park, I soon caught sight of the eerie abbey ruins. It was originally founded in 1251 by Blanche de Castile (1187–1252), the mother of Saint Louis, or King Louis IX, (1215–1270). The great Gothic arches of this royal abbey once sheltered many exquisite treasures, but are now home to the wild creatures of the night and—it is said—several ghosts. Bizarrely, although Blanche de Castile chose to be buried here, her actual tomb has never been found.

As I wandered through the fallen pillars, I passed a tramp who lay sleeping in a doorway. I must have disturbed him, as he turned over, pulling his blanket up to cover his head, no doubt to blot out the horrors of his world.

The Cistercian abbey was plundered many times over the centuries, but its eventual downfall came about during the French Revolution, when the nuns were evacuated and the building was sold to a stone merchant. I found it a very unnerving site and was not surprised by its ghostly reputation. At night, the torch-lit processions of both monks and nuns have been seen, and the sound of organ music and chanting can sometimes be heard. But the best-known phantom is the figure of a local lord, who committed suicide by leaping from the highest window of his nearby château, throwing his hunting dogs out before him. If, at night, you meet this apparition, emerging from the nearby woods and heading towards the abbey ruins, followed by his hounds, then remember to cross yourself, for you are in great danger.

Behind me, the tramp was rising unsteadily to his feet. I wondered whether he had slept the night here? If so, he is a braver man than I was.... As I returned to the safety of my car, I reflected that I am now not far from Blandy-Les-Tours Château, perhaps one of the most haunted sites in France. The many supernatural legends surrounding this place have been well documented since the eleventh century.

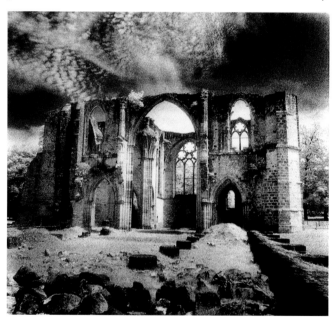

above and facing page
Dammarie-les-Lys Abbey

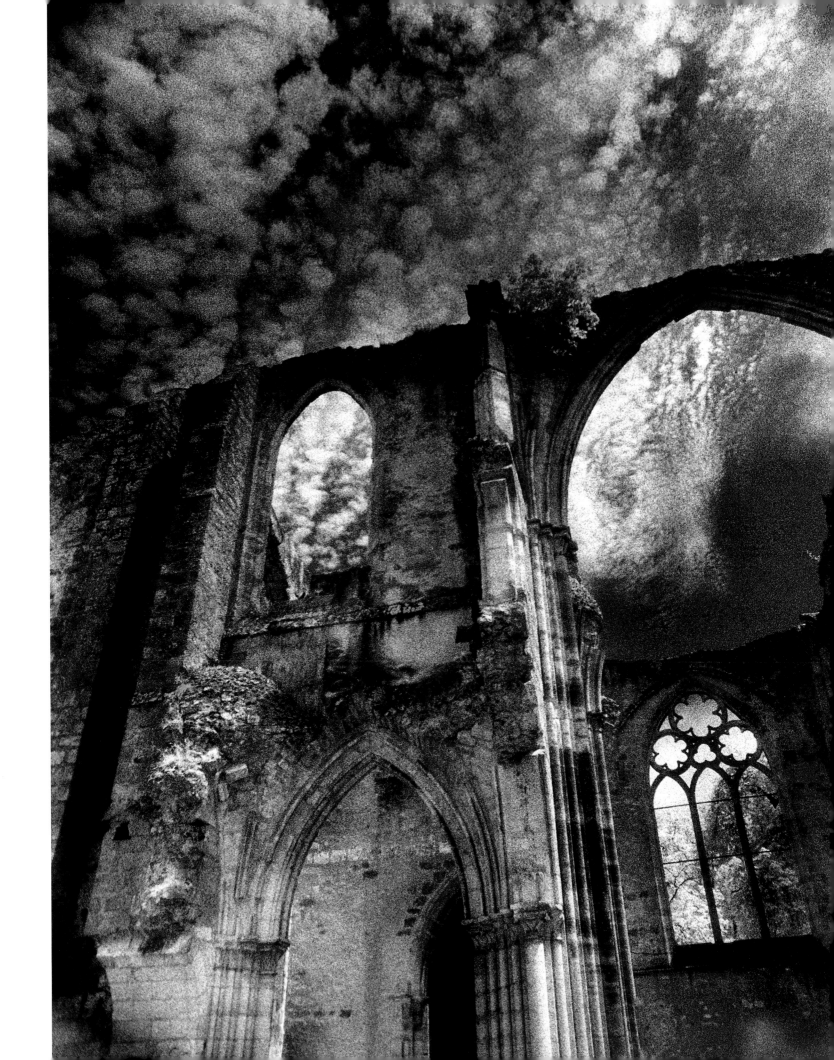

Ancient Spirits
- 13 September -

The massive towers of this castle dwarf the picturesque village of Blandy. Its many tales of supernatural phenomena make it one of France's oldest and best-documented hauntings. Local tradition says that the ghosts of many of its former residents revisit it on the anniversary of their deaths. The women never come without chains, which they scrape and rattle along the walls to terrify the living. Sometimes they leave darkened handprints burnt into the walls and doors. Every year, on the night of 2 November, the château's chapel witnesses an equally strange and terrifying spectacle. At midnight, the lids of the tombs are said to slide slowly open to release their white-shrouded corpses. The church candles then light themselves to guide this ghostly throng around the sanctuary tower as they chant the Dies Irae and the church bell begins to toll.

There are other disturbing apparitions, including the spirit of one of the oldest lords of Blandy, who lived in the eleventh century. This evil man had committed many crimes, including murdering his own brother. His remorseful ghost apparently appears, covered in a bloody shroud, his skeletal hand brandishing a dagger. He was cursed by his many victims, and at night his bloodied apparition runs from tower to tower, from room to room, in eternal torment.

The most famous spectre is that of the count of Dunois, who leads his knights to the original gates of the castle at midnight on 6 January. This is Epiphany, the 'Day of the Kings' or 'Old Christmas Day'. It was Dunois's ancestors who restored the château during the Renaissance. At the foot of the highest tower is the entrance to an arched underground tunnel. For centuries this too has been believed to be the retreat of evil spirits, of hideous monsters that guard hidden treasure.

I saw a group of very young schoolchildren arrive, some dressed in mock armour and carrying swords. As they listened to the castle's history, all seemed entranced, while a few—judging by the expressions on their faces—were a little scared. Talking to the custodian, she told me they were from a local school and that the ghost stories were a very popular aspect of the visits. 'Personally I think they are the result of people with too much imagination,' she grinned. She then kindly photocopied for me the various legends and gave me what she described as the 'true history of the castle'.

Over dinner I thought about what the custodian had said. Nowadays we live in a world that demands an instant, rational explanation for everything. Science is now our God and the power of our innate imagination is being suppressed by the overwhelming onslaught of technology. Where, I wondered, would the rich literary and artistic heritage of France be without the freedom that imagination brings? These hauntings are in the classic genre of ancient ghost stories. Although they may seem at first far too incredible to believe, every legend has a basis in truth, and I was interested to read in the custodian's notes that the first traces of the castle, dating from the fifth century, had been built over an ancient burial site. In recent times, when the municipality decided to level the land in between the nearby Church of Saint Maurice and the château, they discovered a dozen ancient sarcophagi containing the skeletons of twelve knights and their armour. Let's hope their spirits are now at rest, and that the look of wonder on the faces of the schoolchildren never fades.

facing page
Blandy-les-Tours Château

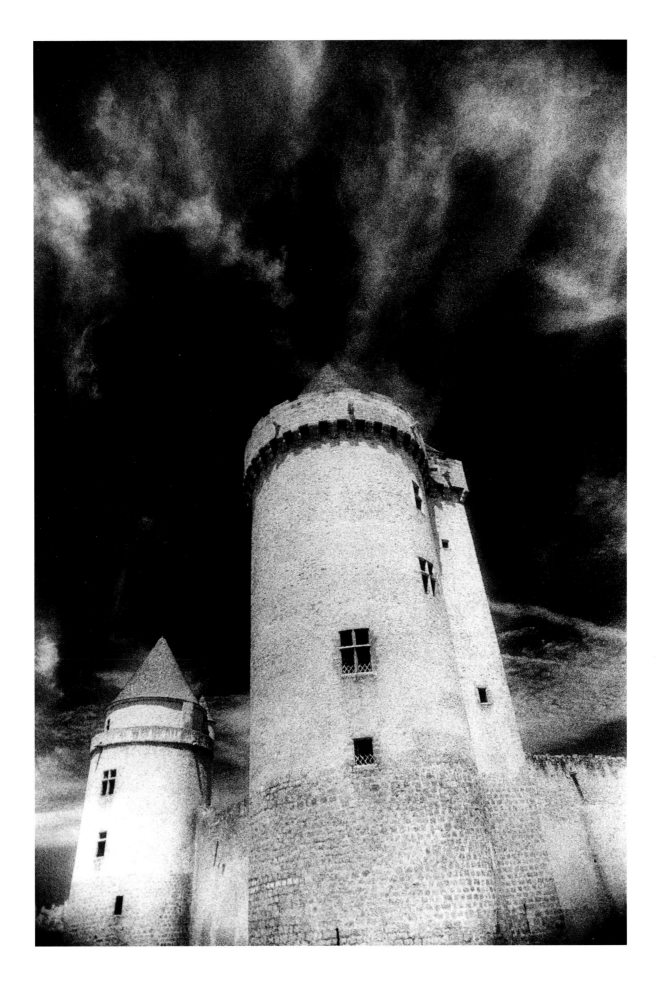

Alone
- 14–15 September -

Some years ago, at a dinner party in Paris, I had a long conversation with a film director who was particularly interested in the fantastic and supernatural. We discussed a script that I was writing; he was trying to think of locations in France that might be suitable for shooting. 'Have you ever been to Raray Château?' he asked. When I said I hadn't, he continued: 'It was chosen by Jacques Cocteau as the location for his masterpiece *La Belle et la bête* (*Beauty and the Beast*), and is a truly fairy-tale mansion, surrounded by enchanting statues and set in magnificent grounds. It is only some forty miles north of Paris.' He believed that it was haunted, he said, and that the story, if he remembered it correctly, concerned a young girl, a servant of the château in the seventeenth century, who had hanged herself in the woods near the house. She had had an affair with either one of the members of the family who lived there, or another member of the staff who had rejected her. However, the most tragic part of the story was that her little boy was found wandering in the woods alone, badly injured. It seemed that she had either tried to kill him first, but had not succeeded, or that she suddenly had been unable to go through with the deed. Whatever the truth, it is this lonely boy's ghost that has been seen in the woods there, no doubt still searching for his mother.

I never forgot this conversation, and last night I re-read Charles Perrault's classic fairy tale. On my arrival at Raray Château, I saw immediately why Cocteau had identified this house with the story. Although the beautiful grounds to the rear of the château are now a golf course, and the mansion itself an exclusive hotel, it has been renovated so subtly that none of its majesty has been destroyed.

As I walked down the long avenue in front of the château, I was thrilled by the sight of the two extraordinary arcades of statues and busts. On top of the walls are hunting scenes that include no fewer than forty-four dogs, a stag and a wild boar. Beneath these are recesses containing the figures of Roman emperors and empresses and Greek gods and goddesses. The eyes of these haunting statues seemed to be seeking me out. If only they could speak, I might learn more about the ghost of the unfortunate little boy.

In the clubhouse and offices to the side of the château, I found a female staff member who told me some of the building's history, which can be traced back to the thirteenth century and a family called Bouteiller. But the house as it stands today, the grounds and the statues, were the creation of one Nicolas de Lancy at the start of the seventeenth century. De Lancy was a councillor to King Louis XIII (1601–1643) and chamberlain to the king's brother, Jean-Baptiste Gaston, the duke of Orléans (1608–1660). I asked this staff person about the ghost of the little boy: she knew nothing about him, but she told me that she did not come from this region of France, and that she was too terrified by the idea of ghosts even to consider that they might exist. However, she thought that I should see the old gateway to what was once the park, known as the 'Gate of the Unicorn' or the 'Red Gate'. She found it very beautiful but unnerving.

facing page
Raray Château

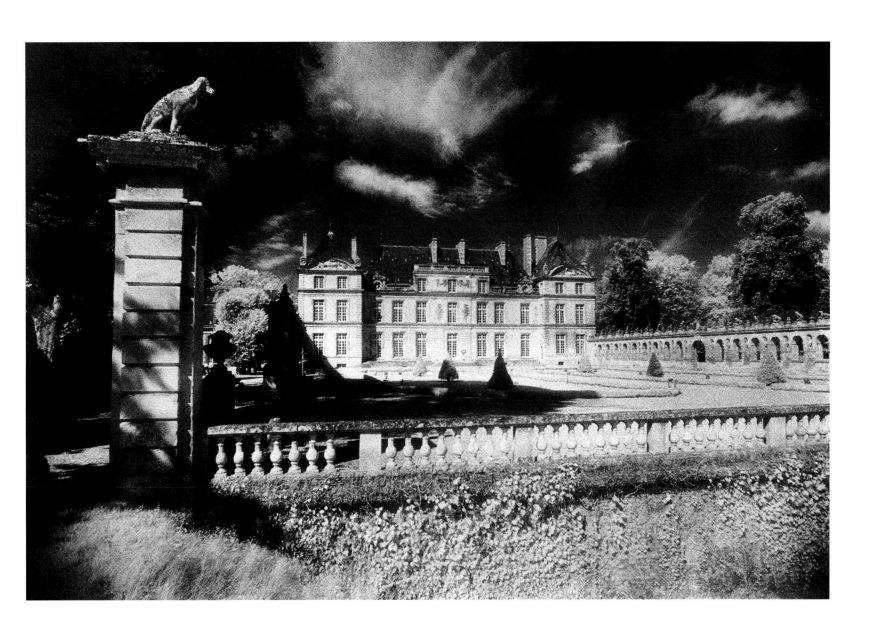

I spent most of the afternoon photographing the château and statues. In the bright sun, the shadows on the faces of the ancient gods made them appear like a gallery of phantoms from the underworld. Later, I walked towards the woods and the famous arch.

The figures on the gates evoke the legendary chase of the unicorn and conjure up an air of mysticism, an entrance to another dimension. Just as I finished taking some pictures of them, a middle-aged man carrying his golf clubs approached through the arch. Smiling, he asked what I was doing. He said that he found the château, the grounds and the statues a wonderful fantasy world, a great relief from his mundane and oppressive office in Paris. Here, he said, he could relax and let his imagination run wild. I asked him about the ghost story I had been told, but he knew nothing about it either. However, towards the end of our conversation he suddenly looked at me with a more thoughtful expression and said that he remembered an incident that had taken place the previous summer, which might be relevant to the ghost of the little boy.

'I had been playing here one weekend with a business friend,' he recalled, 'and my wife had brought our children up from Paris for lunch. The kids played in the grounds while she sunbathed. Eventually we all met up near the arch and started to walk back to where our car was parked. I asked my four-year-old daughter if she had enjoyed herself, but she shook her head and said no. When I asked why not, she took her time to reply, but eventually said that she was afraid of the statues. I told her that they weren't real, so there was no need to be frightened of them, but she said one of them had moved. "Impossible," my wife said. "But it did, it did," my little girl shouted. "It was a little boy standing in the woods near the arch. He wasn't real." We just ignored her then. Children are always inventing imaginary beings, aren't they?'

The historic town of Chantilly is only a short drive from here; I intend to spend the night there before visiting its magnificent château in the morning. It is somewhere I have always wanted to photograph, and I am told that Saint Simon in his *Memoires* recounts a particularly unusual and frightening ghost story associated with this vast estate.

facing page
Red Gate, Raray Château

pages 46 and 47
Statues, Raray Château

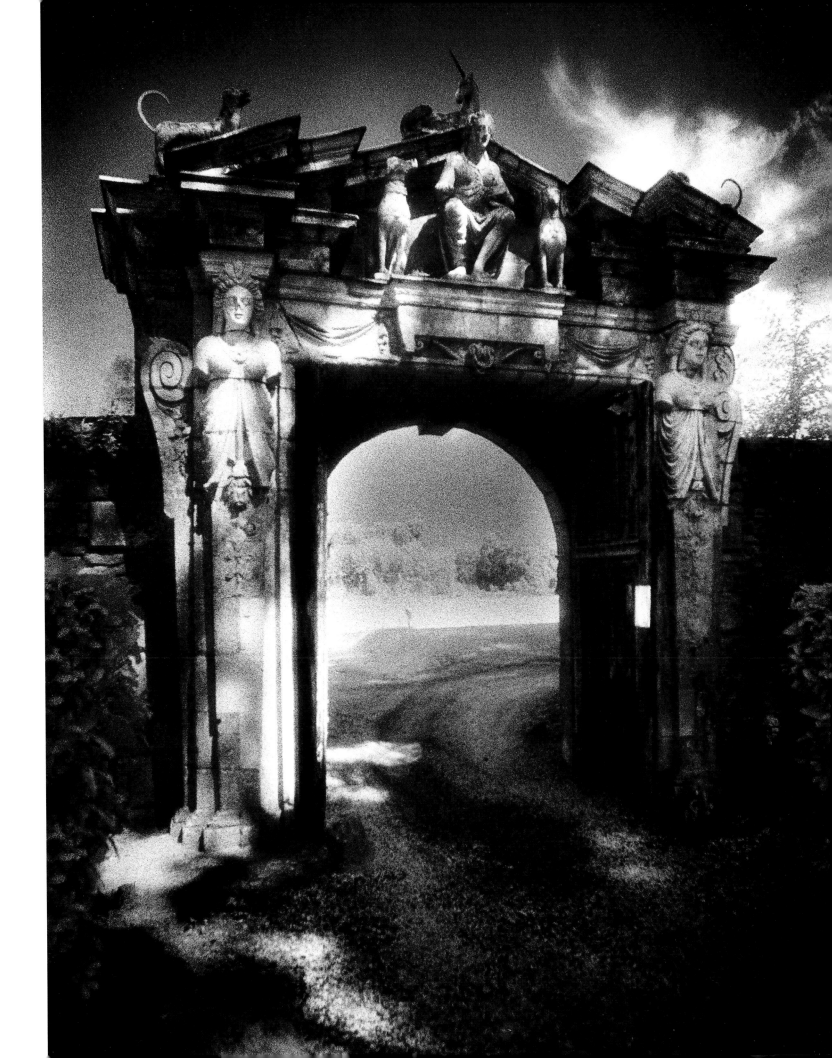

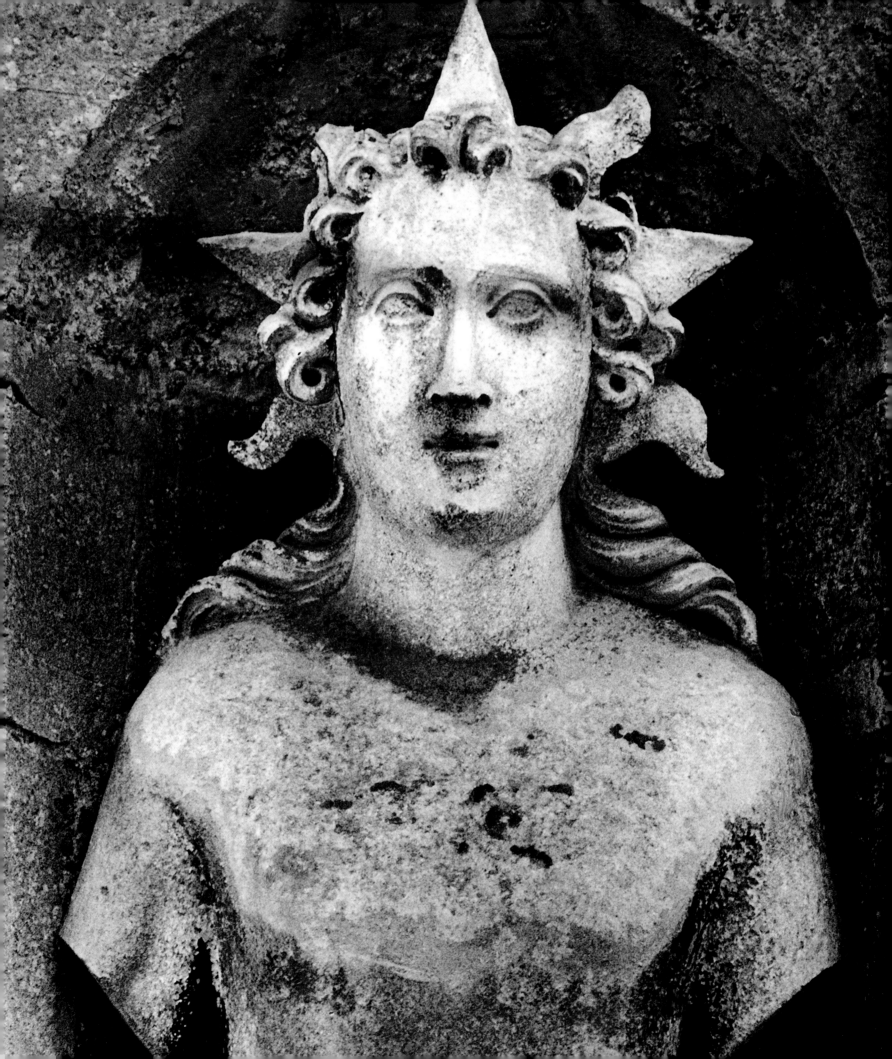

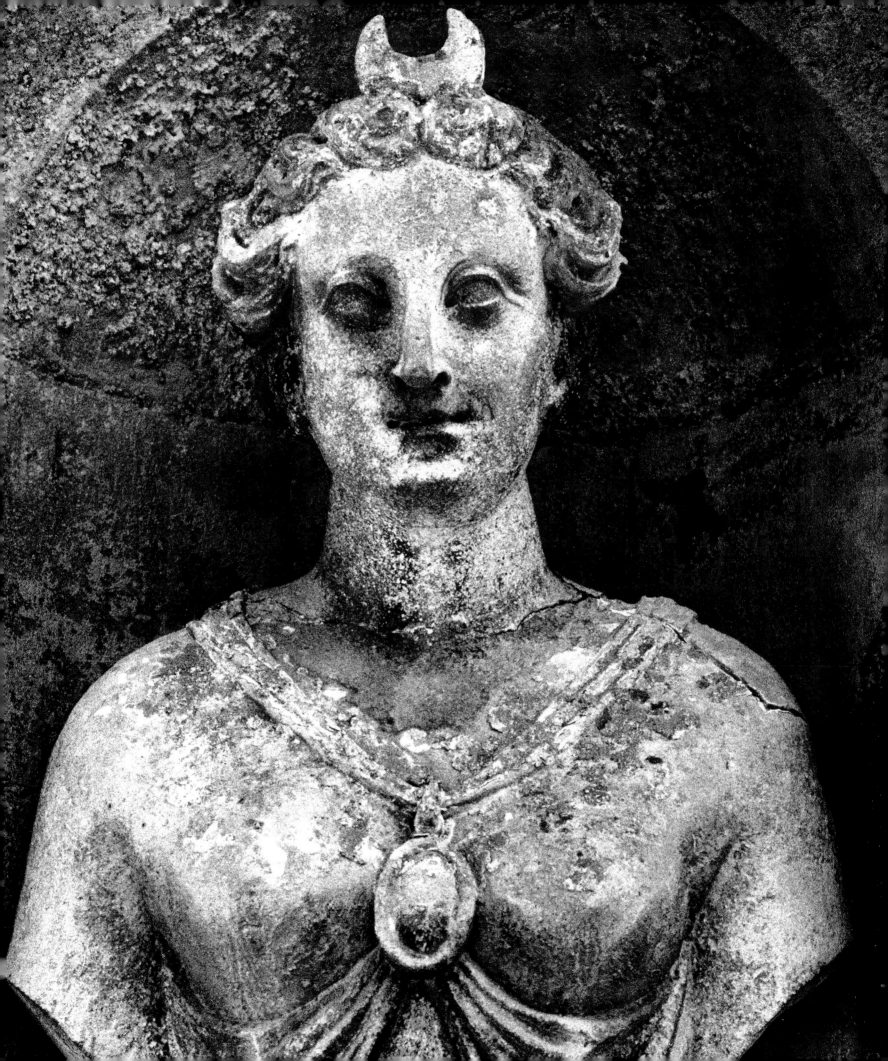

PICARDY – CHANTILLY CHÂTEAU

The Enchanted Ring

- 16 September -

Chantilly Château is one of the jewels of French heritage; its history dates back more than 2,000 years to when Cantilius, a native of Roman Gaul, built a fortified dwelling on this site. Between the fifteenth and the nineteenth centuries, the château was in the possession of the Montmorency and Condé families, two of the most powerful dynasties in France. They amassed a superb collection of paintings, drawings, books and objets d'art that has now been bequeathed to the State.

Theirs was a privileged, eccentric existence. The seventh prince of Condé, who between 1719 and 1735 had the most beautiful stables in the world built for his horses at Chantilly, stated that he himself would be reincarnated as a horse. Bizarrely, another ancestor of the Condé family sometimes believed he had been transformed into a dog and would often be found barking in the grounds. Madame de Sévigné (1626–1696), chronicler of the age, relates in her memoirs that when Louis XIV visited Chantilly in 1671, his chef—fearing that the fish course would be served late—committed suicide. Today the château and grounds remain a fantasy world of lakes, fountains, statues and tiered waterfalls.

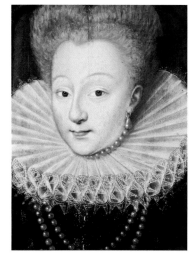

Chantilly is haunted by the ghost of Louise de Budos (1575–1598), the second wife of Henry I, the duke of Montmorency and supreme commander of the French armies. In February 1593 Henry had come to Pézenas to attend the funeral of his youngest son, and it was there that he met Louise, a young and pretty widow. Their courtship advanced quickly and they married the following month. However, their union was not a success, and in his *Memoires* (1752), the Duke of Saint-Simon relates that Louise, neglected by her husband at Chantilly, was known to have had many secret meetings with a stranger. One day she and the man were seen locking themselves into one of the château's offices where, the following morning Louise was found dead lying on the ground, her head twisted with her face hanging over her spine, yet without any signs of pain and there was a strong smell of sulphur pervading the office.

Strangely, at his wife's funeral, Henry fell uncontrollably in love with Louise's aunt, Madame de Dizimieu, who had discovered her niece's body. Three months later he asked her for her hand in marriage. Why did Henry experience such sudden emotions and fall so easily in love?

above
Louise de Budos, anonymous, sixteenth century

facing page
Chantilly Château

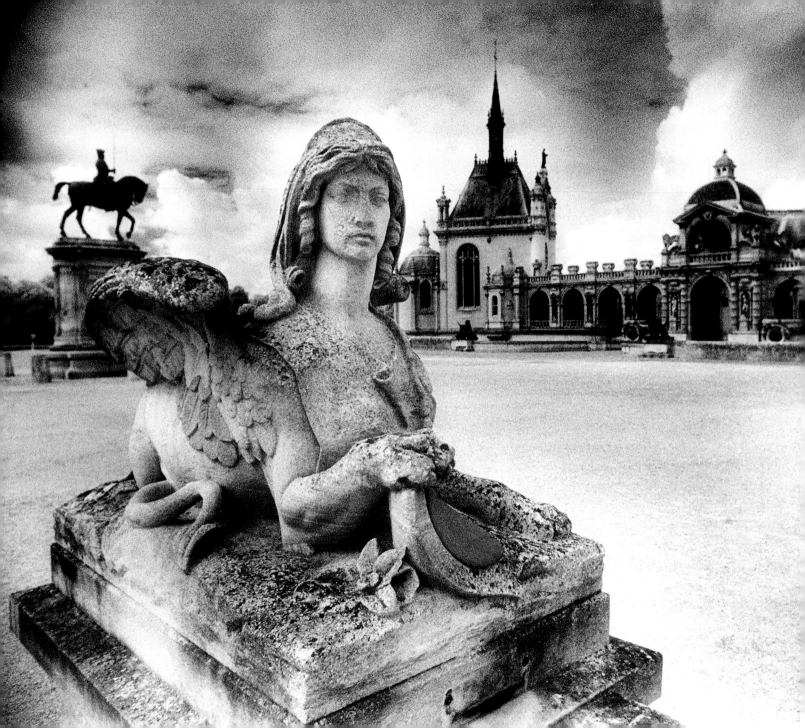

According to Saint-Simon, the duke had fallen under the spell of an enchanted ring that a beggar had given to Louise de Budos before her marriage to the duke, and which was then stolen from her corpse by Madame de Dizimieu. The ring was capable of making others fall madly in love with its owner. Consequently, when Madame de Dizimieu threw the ring away in the gardens of Ecouen, the spell was broken and the duke divorced her soon thereafter.

Just after this separation, the ghost of Louise de Budos appeared for the first time at Chantilly Château. Then, like

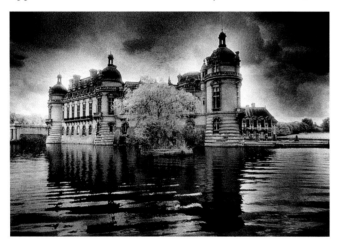

an ill omen, it returned to the mansion on the eve of the death of each of its owners. In 1685, just before the death of Louis Armand I of Bourbon, a prince of Conti and the first-born of the House of Condé, her spectre was seen at the window of the Weapons Room. The prince's squire, Vervillon, who witnessed the apparition, tried to explain the mystery in vain. Soon afterwards the prince was struck down by a violent attack of the pox. Was this due to the strange curse of Louise's ghost at Chantilly, or was the prince simply contaminated at Fontainebleau by his wife who had contracted the same illness? Whatever the reason, the strange circumstances surrounding the death of Louise de Budos strongly suggest that supernatural powers were at work.

As I wandered through the grounds at Chantilly, photographing the statues and temples, I could sense the ghosts of the past all around me. It is a silent world of decadence and beauty, which enriches one's soul through the thoughts and visions of some of Europe's greatest poets and artists.

Tomorrow I must turn my attention to another mystery: at the fortress of Gisors in Normandy, there is a centuries-old belief that the deep tunnels under the ancient castle still hide the esoteric treasure of the Knights Templars.

above and facing page
Chantilly Château

The Mystery of the Templar Treasure
- 17–18 September -

Gisors—the name means 'Land of the Secret of the Vulcan'—has always been of great strategic importance. Situated within the Vexin, the plateau at the historic frontier between the Île-de-France and Normandy, its castle dominates the medieval city and reflects Franco-English history in the phases of its construction. William Rufus, William the Conqueror's son, built the main keep in 1096 and Henry Plantagenet (1068–1135) fortified it, building the outer walls. Philip II constructed the second keep, the Tour du Prisonnier, in the twelfth century. The labyrinth of vaulted cellars beneath the castle also dates from this time, and it is these dark, damp tunnels that are said to hold a great secret. For the fortress is renowned for its association with the Knights Templars and their esoteric treasure.

By the beginning of the fourteenth century the Templars, despite their religious vows of poverty, had become one of the richest and most powerful forces in Europe, paying allegiance only to the pope. The French king, Philip IV 'the Fair' (1268–1314), felt threatened by this disciplined but arrogant military force; unable to get his hands on their wealth he was desperate to destroy them. Pope Clement V was politically indebted to Philip for his position, and agreed to suppress the Templars on charges of heresy. On Friday 13 October, 1307, all the known Templars in France were arrested and their property confiscated. Many were pre-warned of their fate and the vast wealth that the king so avidly sought was never recovered, so the whereabouts of the 'Treasure of the Templars' remains a mystery. Was it material wealth, or something more powerful, such as the Ark of the Covenant or the Holy Grail, which the original nine Templars are said to have stolen from the Temple of Solomon in the twelfth century? Could the Cathars have once hidden it in Montségur Château (see pages 164–173) Did the priest at Rennes-le-Château discover it (see pages 158–163) Alternatively was it concealed in Chartres Cathedral (pages 36–37), or here at Gisors? Or was it, as has been suggested, not a physical treasure at all, but a great secret that—if revealed—would destroy the Catholic Church?

Jean de Chalons of Nemours, Troyes, an important member of the Order, gives credence to the most widely held belief that at least part of the treasure was hidden beneath the château at Gisors. He testified that: 'On the evening before the raid, Thursday October 12, 1307, I myself saw three carts loaded with straw, which left the Paris Temple shortly before nightfall, also Gérard de Villiers and Hugo de Chalons, at the head of fifty horse(men). There were chests hidden on the carts, which contained the entire treasure of the Visitator Hugo de Pairaud. They took the road for the coast, where they were to be taken abroad in eighteen of the Order's ships.'

It is known that the Templars had ships waiting off the coast of Normandy to take themselves and the treasure out of the country, but they may have been prevented from reaching their destination, and Gisors would have been directly on their route.

The present curator of the château, an intelligent young man, but definitely not one who belives in ghosts or the supernatural, was very knowledgeable on the castle's history.

facing page
Detail on a doorway of the Church of Saint Gervais and Saint Protais, Gisors

When I asked him about its connection to the Templars he said that this was exaggerated and that they had only occupied the building for three years between 1158 and 1160. He took me into the vaults below the main keep and showed me where they had been vandalized by treasure-seekers. It appears that the whole of this mysterious city is honeycombed with a complex system of underground tunnels, some of which are open and others of which remain sealed.

In 1929 a previous guardian of the castle called Roger Lhomoy began his own extensive explorations in these subterranean corridors: he reported that he had discovered a large chapel containing a stone altar and a tabernacle that also appeared to be an initiation chamber. On the walls were statues of Christ and the twelve apostles supported by stone ravens, he claimed, and along the walls many sarcophagi, also in stone, with thirty enormous iron coffers arranged in columns of ten. He was judged to have been insane.

In 1962 Gérard de Sède published a book entitled, *Les Templiers sont parmi nous, ou l'énigme de Gisors* (*The Templars Are Among Us*, or *The Enigma of Gisors*), which rekindled the debate on the whereabouts of the treasure. It inspired such controversy that the then minister of culture, André Malraux, ordered an official excavation by the army in 1962, then another in 1964. Later that year he declared that they had found nothing.

The city has a very ancient feel and, walking through the narrow streets, I passed the magnificent Gothic Church of Saint Gervais and Saint Protais, where a carving on one of the wooden doors reminded me of the *Baphomet*, the Islamic idol that the Templars were accused of worshipping in their initiation ceremonies (see Salers, pages 134–135). Amongst the other heretical charges brought against them were ritually spitting, trampling and defecating or urinating on the cross, contempt of the Holy Mass and denial of the sacraments, as well as infanticide and homosexuality. Jacques de Molay, the last Grand Master of the sect, was held prisoner in Gisors before he was tortured and then burnt to death in 1314.

I returned to the fortress in the early evening and the curator and I continued our discussions. I wanted to know if there were any reliable books on the history of the Templars' brief occupation of the castle, and he kindly offered to come with me to the local bookshop and show me what was available. As we walked down the hill I asked him if he had read Dan Brown's best-selling book, *The Da Vinci Code*. He said that in his opinion it lacked historical accuracy, like so many other books on the Templars that have been written recently, and that such books just cause confusion. 'If I tell visitors that there never was any treasure hidden here, they simply insist that it must have been stolen. They want to believe in its existence so badly that nothing I can say will change their minds.'

Today the great tower of this once impregnable castle is unsafe, its foundations weakened by the clawing hands of those who have dared to try and discover its secrets in the dead of night. But many of these nocturnal fortune hunters have been frightened away by the eerie whispers and shadowy figures that are said to haunt the ruins, no doubt remnants of the strange initiation ceremonies and satanic rites that the Templars are rumoured to have performed here.

facing page
Templar initiation ceremony

pages 55–56
Gisors Fortress

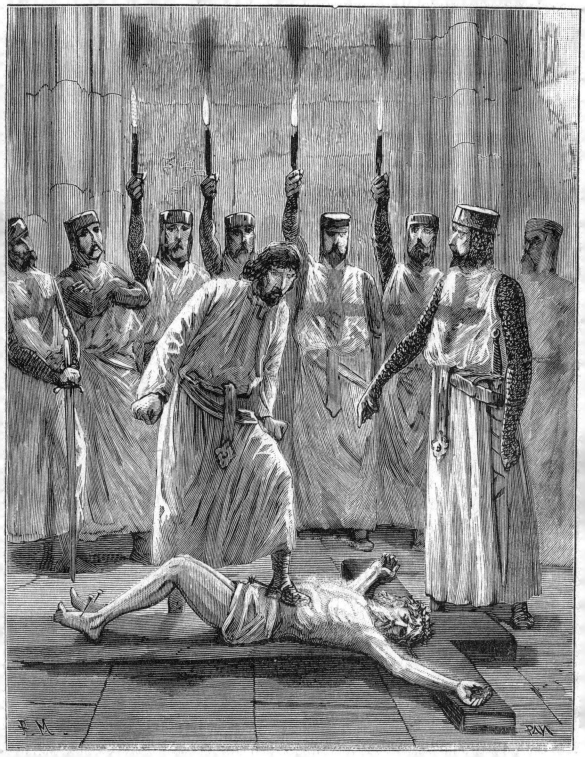

NORMANDY — MORTEMER ABBEY
Lost Souls
- 19–20 September -

The mysterious ruins of the first Cistercian abbey in Normandy lie hidden deep within a valley surrounded by one of the finest beech forests in France. It was founded in 1134 by Henry I (1068–1135), the son of William the Conqueror. The abbey is built on marshland, which in Latin was known as *mortuum mare* (literally, dead sea) and in French is *morte mer*, hence the abbey's name. When I arrived in the early afternoon on a sunny autumn day, everything in this tranquil location seemed perfect. There were goats sleeping beneath the vaulted arches and fish rising within the calm waters of the lake. It was almost impossible to imagine I was standing on the grounds of one of the most haunted sites in France.

In the fifteenth century, the abbey was at the height of its powers, with around two hundred monks owning much of the surrounding lands, farms and houses, including hospices in nearby Rouen. But what had originally been dedicated to the highest religious ideals—poverty, chastity and seclusion from the world—was now largely undermined by the vast wealth it had acquired from its many rich benefactors, who had given lands and money in the hope that they could purchase salvation from their sins in the next world.

By the beginning of the sixteenth century, a slow decline in the order's fortunes had begun due to a dictate from parliament decreeing that non-ecclesiastical appointees would from now on manage the abbeys; the ensuing lack of funds meant that it gradually fell into decay. In 1790 there were only four monks left living within the ruins. During the Revolution they were falsely accused of many crimes, and they were hunted down and executed without pity in the cellar of the abbey. Their blood is said to have been mixed with the wine from broken casks.

I found this cellar had a particularly oppressive atmosphere, the phantoms of these tragic monks continuing to haunt its damp walls. After the Revolution, the abbey was sold to a farmer and changed hands many times over the ensuing years, until the present owner, Madame Charpentier, created a museum here in 1985. During the 1914–1918 war, English officers who were sleeping in the cellar awoke to see four terrifying dark shadows dressed in religious robes standing over them. They described them in such detail that it seems certain that they were the ghosts of the four assassinated monks.

Inside the abbey is the Spring of Saint Catherine, a fountain whose waters are said to have magical powers. During the Second World War, under the German occupation, a British parachutist landed near this fountain at night. Lost and alone in the darkness, he had no idea how to find the farm where he hoped Resistance fighters were waiting for him. Suddenly, out of the darkness, the eerie, cowled figure of a monk appeared, silently signalling to the soldier to follow him. When they arrived at the secret rendezvous, the monk mysteriously disappeared into thin air. When the Englishman told his hosts what had happened they fell silent, knowing that since the Revolution not a single monk had lived in the abbey.

facing page
Wooden statue of a priest performing an exorcism, Mortemer Abbey

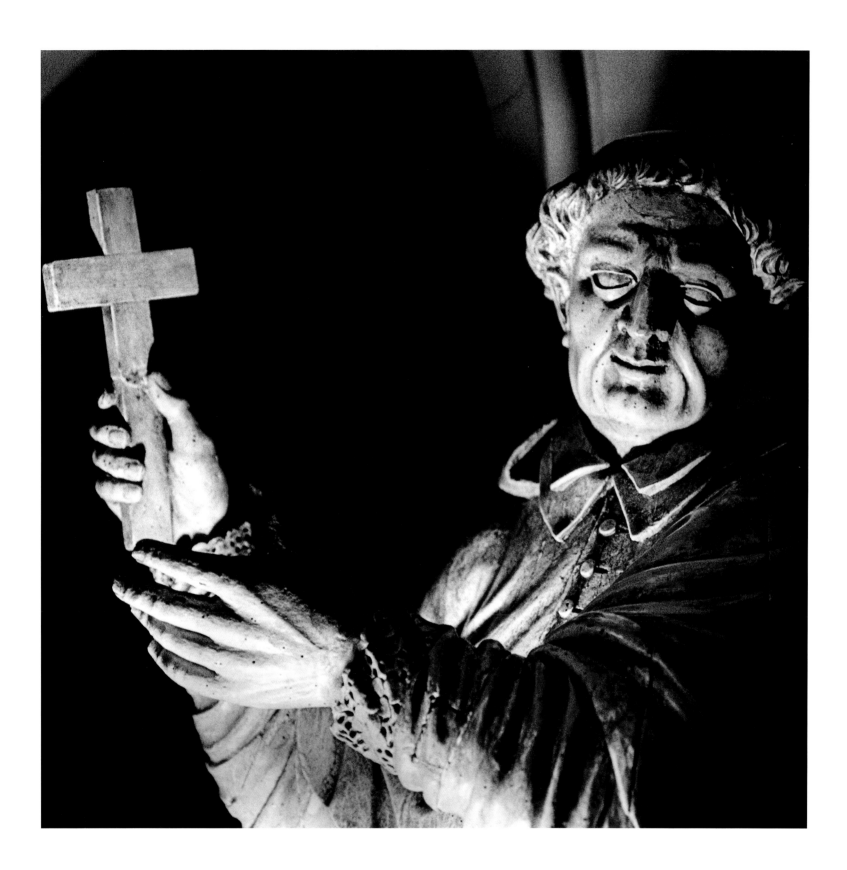

The legend of a female werewolf is recorded in a striking modern painting in the abbey. It seems that, in 1884, a local man, Roger Saboureau, was poaching in the nearby forest when he sensed he was being spied upon. He turned around, and found himself confronted by a large female wolf. Frightened, he fired his gun, killing the beast. He fled deep into the woods. The next day at dawn he returned to the exact spot where he had killed the wolf, only to find his wife lying dead in her own blood. She was said to be a *garrache,* a bewitched woman or werewolf. At the time of the full moon, the demon is still said to be seen wandering the forests and countryside surrounding the abbey

Towards the end of the nineteenth century, a certain Monsieur Delarue, a rich Parisian, became the owner of the abbey and moved there with his wife and children. Almost immediately they were plagued by paranormal phenomena. The children were terrified by objects moving of their own accord, especially in what is known as the Pink Room and the library next to it. They heard footsteps when no one was there, and doors opened on their own as if by a ghostly hand. Sometimes pictures were found in the morning facing the wall or on the ground, but the glass was never broken. More bizarrely, the owners' cars, which were parked in a shed, were sometimes covered with a strange white dust. The Delarue family had the property exorcized in 1921, but left soon after. A disturbing seventeenth-century wooden statue of a priest performing an exorcism can be found in one of the upstairs rooms.

Perhaps the best-known apparition at Mortemer Abbey is Matilda, or the 'Woman in White', whose spectre has roamed the ruins of the abbey and passageways of the house for more than eight centuries. Matilda was born in 1102, the daughter of the abbey's founder, Henry I, and granddaughter of William the Conqueror. At the age of twelve, she was married to the German emperor Henry V; after he died she married Geoffrey Plantagenet, Duke of Anjou. She had a son, Henry FitzEmpress, who in 1154 was crowned King Henry II of England. Matilda's free and frivolous morals led to her father virtually imprisoning her in the Pink Room for five years. Her solitude was so sad and painful that her pale phantom returns to haunt Mortemer in search of redemption. It is said that only sensitive people can feel her presence. There is a legend that, if you see her wearing black gloves, you will die within the year, but if she is wearing white gloves, it is the sign of an impending birth or marriage.

Some recent visitors to the abbey claim to have heard sounds of breathing close to the ancient cloister walls, just as if someone were present, except there is never anyone there. My guide, who appeared to be a very intelligent, rational woman, said that she had often experienced poltergeist activity in the house, including loud noises at night: 'So loud they could shatter the glass in a window.'

The light was now fading fast, the long dark shadows retreating towards the atmospheric ruins as I followed an ancient pathway that circles the building. I began to sense the aura of the 'lost souls' that continue to inhabit its many dark corridors and crumbling walls. Later, back in the comfort of my ancient, oak-beamed bedroom in the nearby village of Lyon-le-Forêt, I couldn't help but think back to those souls at the abbey. Would they ever, I wondered, find the peace their spirits so desperately crave?

facing page and pages 62–63
Mortemer Abbey

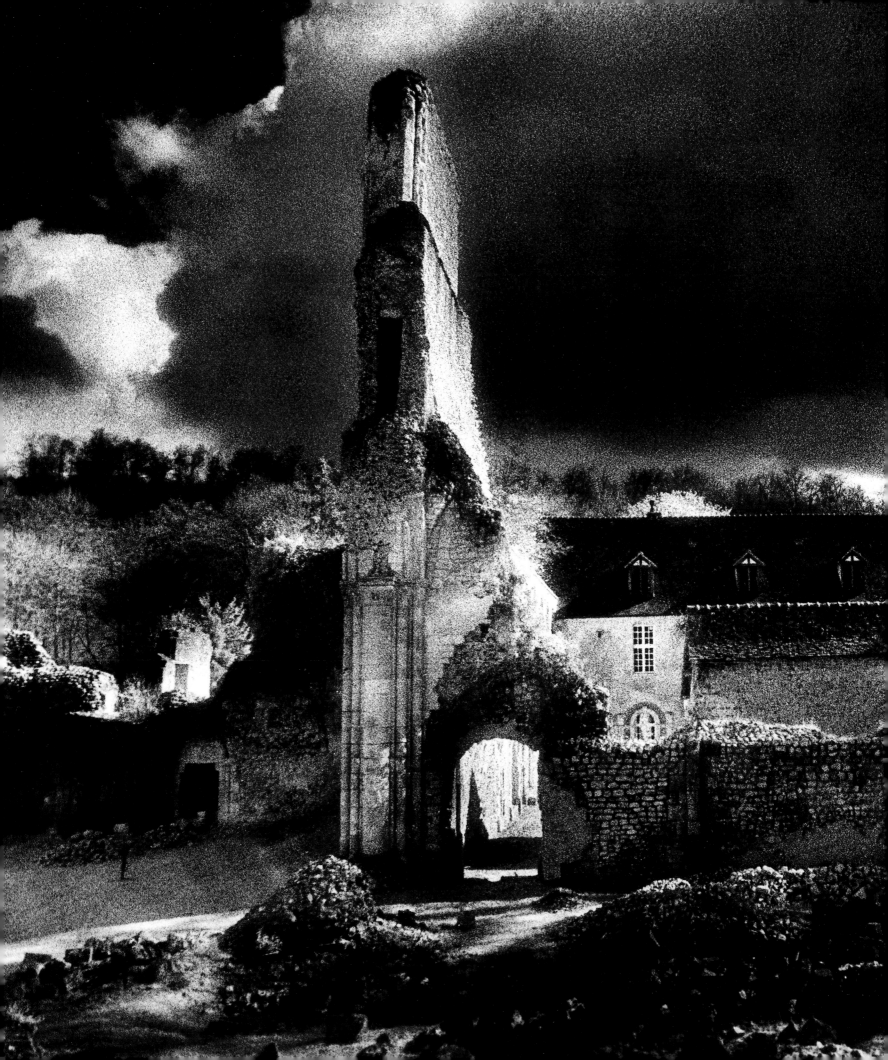

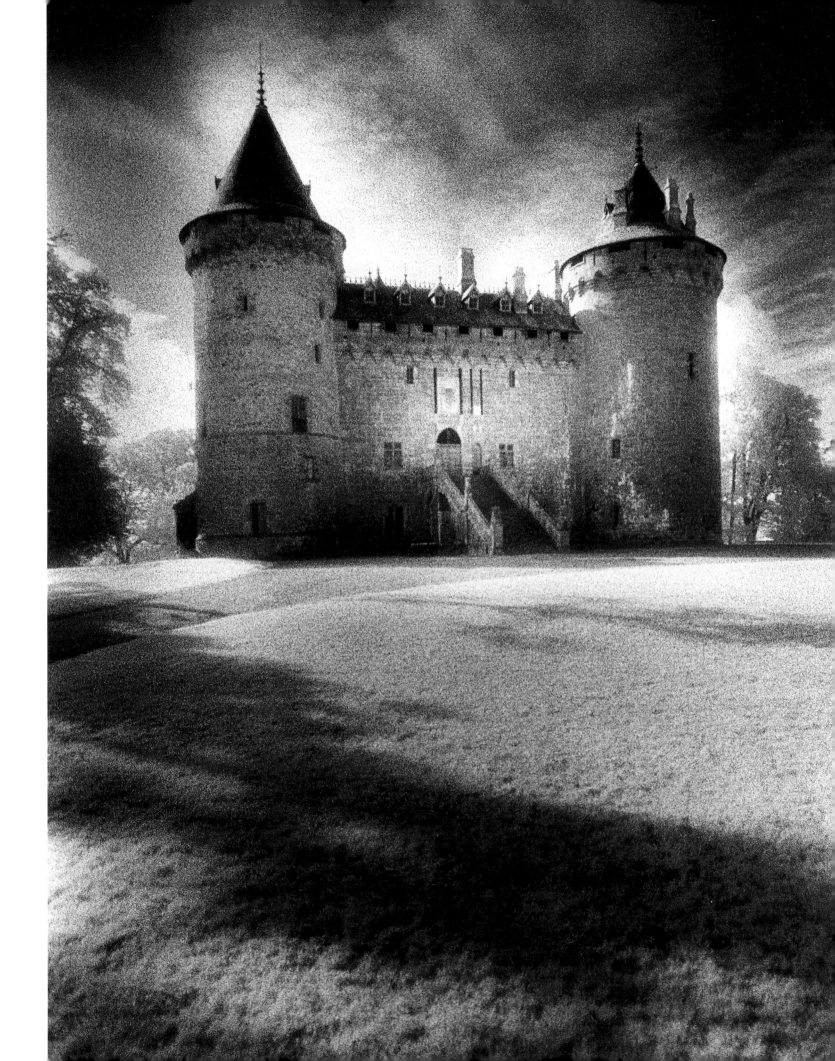

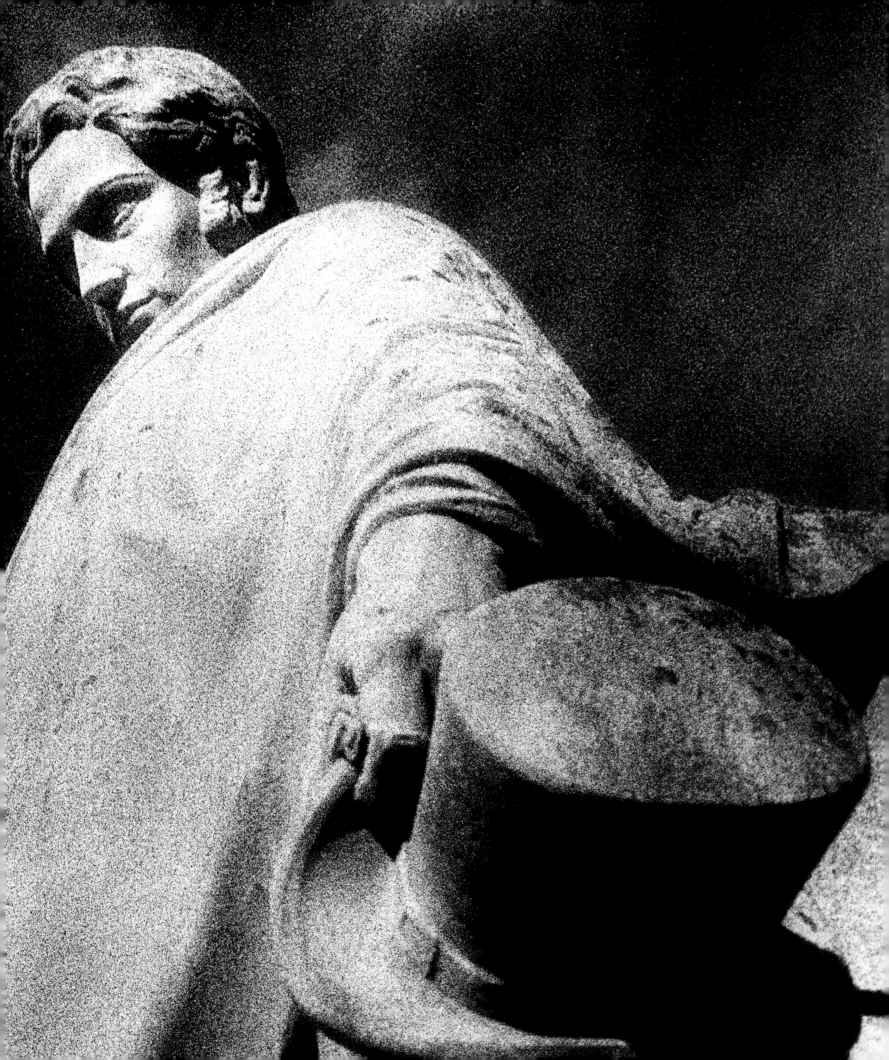

A Taste of Death

- 25 September -

In the thirteenth century, Olivier Tournemine, whose ancestors were later made lords of Hunaudaye, chose to build this massive fortress in an isolated spot surrounded by marshland and forests. My first sight of the eerie ruins filled me with awe. Its five massive, crumbling towers are still protected by a deep moat; it was easy to believe the local saying that 'the devil died of cold here'. The barons of Tournemine became a very powerful feudal dynasty. No one was safe from their cruelty, and the castle became a symbol of fear. To venture into their lands was to risk capture and almost certain death; even within the family treachery and murder were rife, as brother fought brother to gain control of their territory.

There are many horrific ghost stories surrounding this depraved clan and the most gruesome made my stomach churn. A certain lord of Hunaudaye, discovering that his wife had been unfaithful, organized a dinner for just the two of them, serving the heart of his wife's lover. She is said to have relished the meal and asked for more. When her husband revealed the contents she was mortified, swearing that she would soon join her beloved in the afterlife. She never ate again and wasted away. Her body was buried near a pond in the grounds of the château and, every year, on the anniversary of her lover's murder, the ground sinks to form a hole the size and shape of a coffin. The lady of Tournemine then leaves her grave to visit her lost love.

After three days she returns to her tomb and the ground rises again.

During a later period of the castle's history, there existed a rumour that the then lord of Hunaudaye had assassinated his father, his wife and his brother. One winter's night the apparition of a knight visited him, draped in a red tunic. The baron was about to call out for his servants to punish the insolent intruder but, before he could, he caught sight of three ghosts standing behind the red knight. These terrifying spectres opened their shrouds to reveal their gored and bloodied bodies. The knight said: 'Look! the old man is your father, the woman your wife and the young man your brother. They come to seek you out so that from now on you will reside with them.' At that moment a violent storm broke out and the room was struck by lightning. When the lord's servants entered his chamber the following morning, they found his corpse lying on the ground, his eyes transfixed with terror.

As I followed the overgrown pathway around the moat, overshadowed by the massive castle walls, I began to feel uneasy. This is a truly haunting site and I could sense that the spirits from long ago still wander here. The chill of the supernatural was all around me. Later, back at my hotel, I felt tired and isolated. However hard I try to distract myself from the subject of ghosts, I rarely succeed. It would seem that they will always be with me, a part of my existence.

facing page
Hunaudaye Château

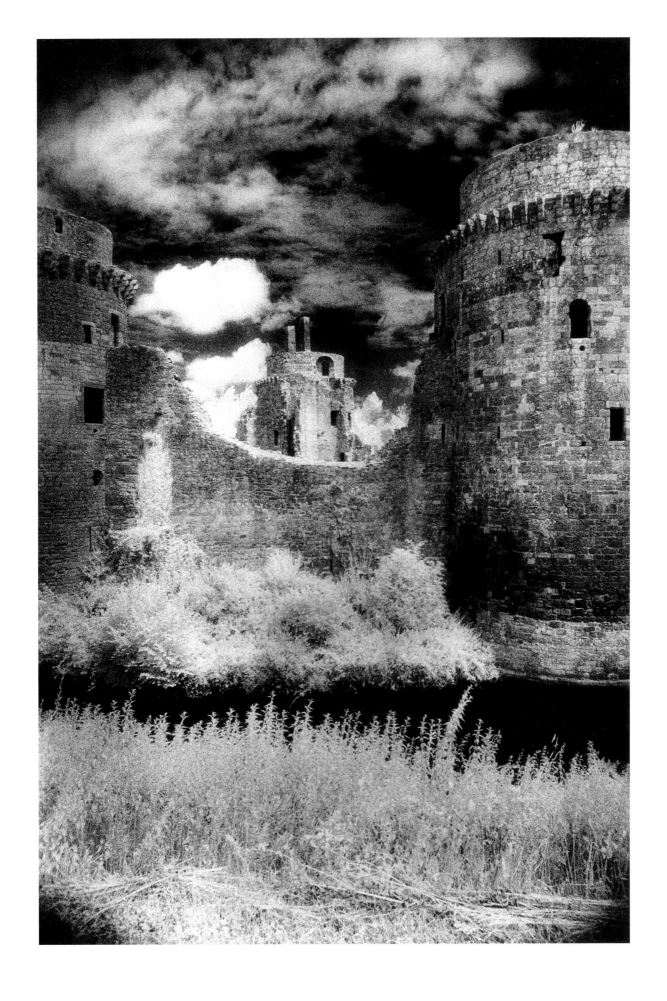

BRITTANY – MENHIR OF GUIHALON

Human Sacrifice

- 26 September -

In Brittany, as in Ireland and their other kingdoms, the Celts have always clung fiercely to the traditions and customs of their forefathers, and this is why the sacrificial stones and sacred trees of their lands were never destroyed. As I followed a narrow pathway through a dense forest of ancient oak trees, I sensed that it was leading me to a site where the aura of these arcane religions can still be felt. Entering a clearing, I saw the massive, dark, upright stone—the menhir—standing before me, a small pool of water at its foot.

This is said to be a haunted place, where strange forces and evil creatures have been both seen and heard. Some years ago, a local farmer discovered a distressed American tourist standing in the road near the woods. He was trembling with fear; it was only later, in the warmth and security of the farmer's house, that he was able to describe his experience. He had visited the stone as part of his archaeological studies and, as he was drawing a plan of the menhir's alignment, he had suddenly felt paralysed by some powerful force, unable to move in any way. Everything, he said, went very quiet: where there had been a breeze, now nothing stirred. Then, on the opposite side of the clearing, he saw a figure, a kind of demon, with long, hairy arms and legs, but in some sense human. It seemed to watch him for an eternity until, with a strange, unearthly groan, it disappeared into the undergrowth on all fours. Rigid with fear, the American remained rooted to the spot. It was only when he realized that the paranormal force was no longer holding him there that he was able to flee from the forest.

The Druids—the word means 'the man by the sacred oak tree who knows the truth'—worshipped both the sun and the moon, and conducted their pagan ceremonies according to the position of the stars and the planets in the heavens. They were known to perform human sacrifices by stabbing their victim in the back and foretelling the future from his or her convulsions. They also believed that the soul was immortal and that it could live on in another's body—whether animal or human—after death. As I remained in the clearing, I reflected that we have chosen, whether consciously or subconsciously, to forget or dismiss much of the arcane knowledge of our ancestors in the pursuit of more immediate material and scientific gain, thus neglecting the powers of nature and the supernatural. We would appear to do so at our peril.

And now night falls,
Me, tempest-tost, and driven from pillar to post,
A poor worn ghost,
This quiet pasture calls;
And dear dead people with pale hands
Beckon me to their lands.

– Ernest Dowson, from 'In A Breton Cemetery', 1899

facing page
Menhir of Guihalon

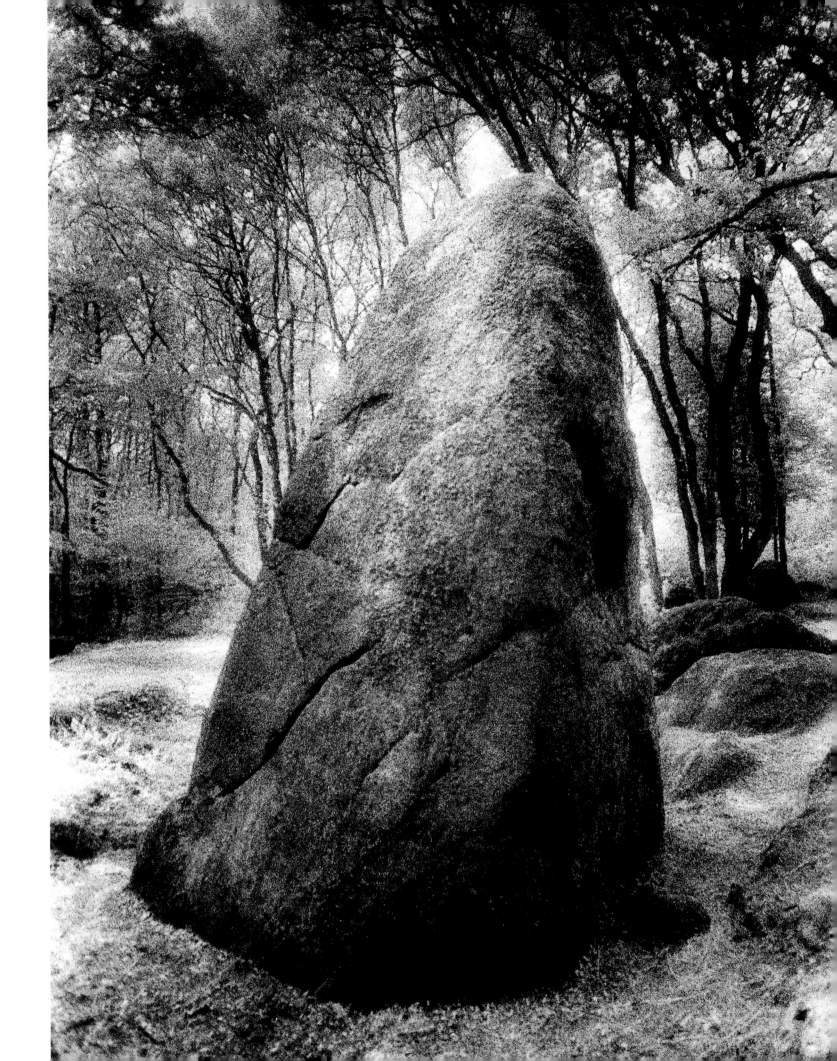

BRITTANY — ANKOUS OF THE CHAPEL OSSUARY
OF SAINT-JOSEPH IN PLOUDIRY AND OF LA ROCHE-MAURICE

The Legend of the Ankou

- 27 September -

The relationship between the Bretons and death is profoundly influenced by their Celtic heritage, and the terrifying apparition known as the *Ankou*. Represented by a skeleton holding a scythe, this macabre figure is often sculpted on ossuary walls or on tombs in graveyards throughout Brittany. Tradition says that he wanders the lanes of the countryside at night in a creaking coach or cart drawn by four black horses. He wears a long dark robe and a large hat that conceals his face. Those who hear the sound of the cart—or worse, meet him—are doomed. When there are a number of victims, he is assisted by two other skeletal figures, who hurl the corpses into the wagon. They are then escorted to the 'Land of the Dead', thought to be at the foot of the Monts d'Arrée, where the entrance to the 'Gates of Hell' is in a large area of marshland.

There are many stories about how the *Ankou* came into existence. My favourite is the following:

A nobleman, who was prone to fits of anger and jealousy, loved to hunt. The moment of death and the pain of his victims were his greatest pleasures. One night, on the Sabbath, he decided to join the chase in his forest with some drunken friends. They started to follow a white stag, a magical animal found in many Celtic folk tales. Then, out of the trees

rode a tall figure, dressed in black, astride a white horse. Angry at finding this man on his land, the prince challenged him to a contest. Whoever killed the stag could not only keep the meat and hide, but could also determine the fate of the loser. The stranger agreed, his voice reminding the assembled men of the sound of leaves scraping against the castle walls.

The hunt was over quickly. As fast as the nobleman rode, the stranger had galloped faster, the night wind tugging wildly at his cloak. And when the prince was stringing his bow, the stranger had already fired his arrow with a deathly whistle, the sickening tear of shredding flesh following soon after. The angry prince ordered his men to surround the stranger, bragging that he would bring two trophies back to his hall that night. The stranger laughed. 'You can have the stag,' he said, 'and all the dead of the world. Your joy is hunting? Hunt then! Your trophies will be found across the battlefields and hearth, and they will reek of decay, huntsman.'

As I travelled through Brittany I found many examples of the *Ankou* to photograph. Perhaps the two most frightening are reproduced here. I was particularly struck by the words beneath the figure on the ossuary at La Roche-Maurice that reads, 'Je vous tue tous' ('I will kill you all').

above

Inscription '*Je vous tue tous*' ('I will kill you all'), Ankou, La Roche-Maurice Church

facing page

Ankou, the chapel ossuary of Saint-Joseph, Ploudiry

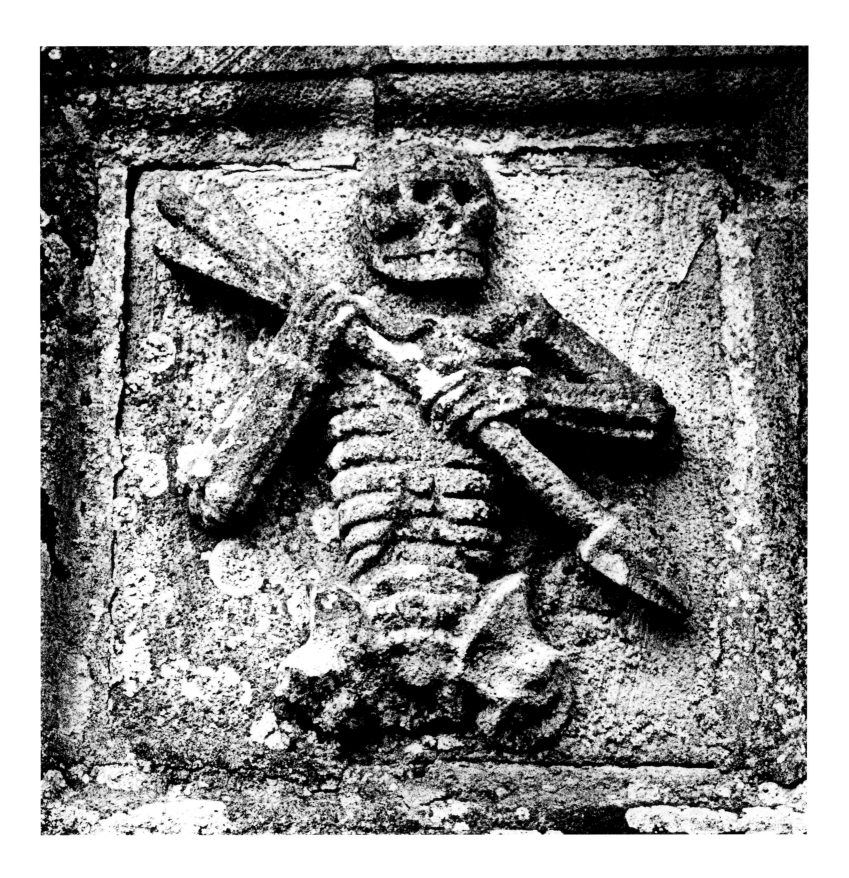

Love Beyond the Grave
- 28 September -

In the picturesque village of Pont-Aven, much loved by the nineteenth-century Post-Impressionist painter Paul Gauguin, I stopped at an old-fashioned bar to ask if anyone could direct me to the ancient Rustéphan Château, which, I had read, was haunted. The barman was new to the area and apologized for his ignorance on local matters, but an old man got up from his table, crossed the room and, placing his hand on my arm, asked, 'Why do you want to know?' I told him I wanted to photograph it for a book I was compiling, and that I was interested in its history. 'Since I was a little boy people have only spoken about its ghosts, not its history, but see for yourself if you can find it,' he said. I got him to mark my map with directions and, as I turned to leave, he added, 'It is a sad story. They must have loved each other very much.'

The château was every bit as hard to locate as the old man had warned, and eventually I found myself wandering in a deep wood on the edge of the village as the light began to fail. Then, suddenly, amongst the tangled undergrowth, I saw some large stones and reasoned that I had to be close. Everything seemed very quiet as I looked around. Then there it was ahead of me—a tall dark tower with an ornate archway and some crumbling walls. This seemed to be all that was left of the ruin. As I approached the doorway, I could sense something was there—but I had no idea what it could be. Once inside, I looked up a broken stairway, but all I could see was the sky. I felt that the tower would make a very atmospheric picture and began to set up my tripod. I was nervous now; it was literally as quiet as the grave and I had left my car some distance away. As I composed the picture, I began thinking of what I had read about the place.

Apparently, long ago, one Geneviève, a noble daughter of the château, had fallen in love with a young man from the nearby village of Nizon. However, he felt destined to devote himself to God and the priesthood, and eventually he spurned her advances. The exact truth of why he ended their affair is not known, but over the centuries their ghosts have terrified the neighbourhood. She appears wearing a green satin dress, with a look of madness, sometimes singing but more often crying. He appears as a 'long, dark shape with luminous eyes.' A coffin has also been seen in the woods, covered in a burial sheet with a candlestick at each of its four corners.

Still staring through the camera lens at the arch, it suddenly seemed to take on the form of an entrance to another world. Pressing the shutter, it was easy to convince myself that I had now captured all that I wanted. My imagination was working overtime and every slight sound made me jump. Returning to my car, I switched on the radio and the headlights and sat staring straight ahead at the road. I had an overwhelming feeling of relief, as if I had avoided something quite dreadful.

facing page
Rustéphan Château

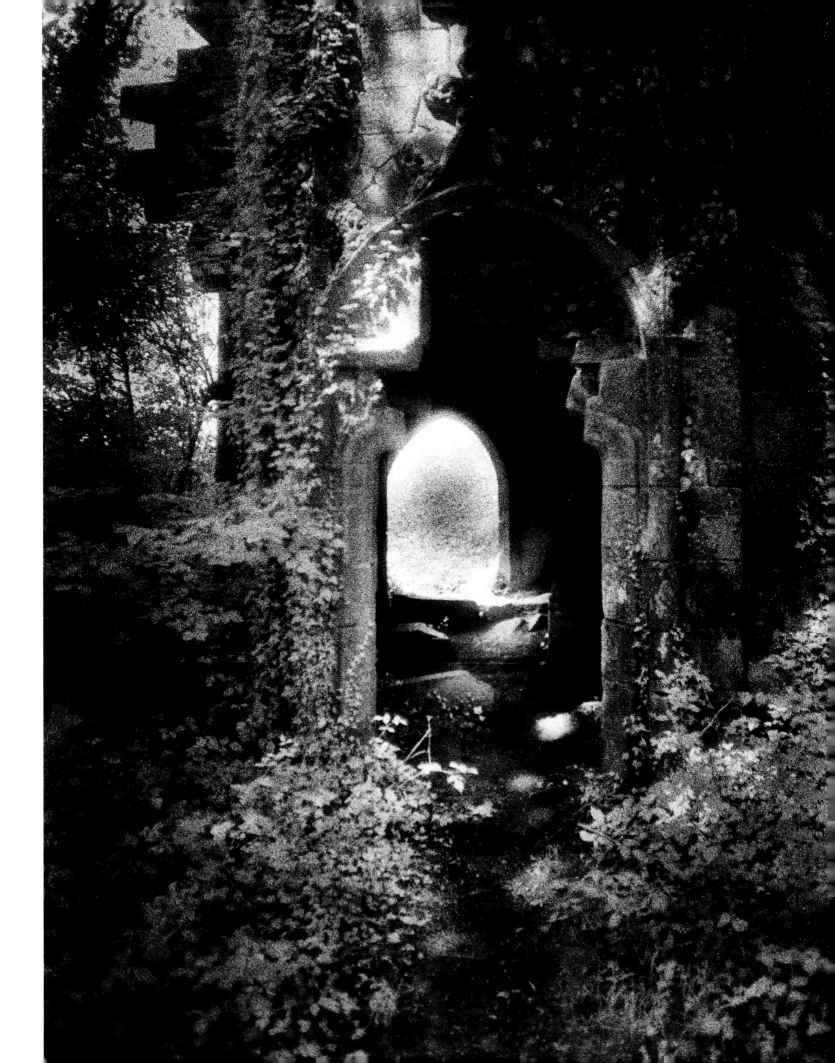

BRITTANY — LARGOËT FORTRESS
The Royal Prisoner
- 29–30 September -

The Château d'Elven, or the Fortresse de Largoët, as it is better known, was once the Largoët county seat, and as I drove down its ancient track I felt the anticipation and excitement that comes with the pursuit of my obsession. Approaching the gates I saw a lodge adorned with statues of giant rabbits, which I later learnt are a tribute to the hare hunt, the favourite sport of the castle's fifteenth-century owner, marshal Jean de Rieux. Parking the car near the lodge I was about to get out when there was a loud crash on the roof, as if someone had hurled a large rock at the vehicle. Stunned and shocked I froze for several minutes. When I finally got out there was no mark, not even the smallest scratch. Unnerved I followed a track through the woods where I eventually spotted two elderly couples. Relieved I caught them up and as I was passing we struck up a conversation. They lived nearby and one of the wives knew a great deal about the castle's history and the marshal de Rieux in particular.

The present fortress includes part of an earlier castle built in the thirteenth century by the Derriens family, passing by marriage to the Malestroit family in 1237, and then to the

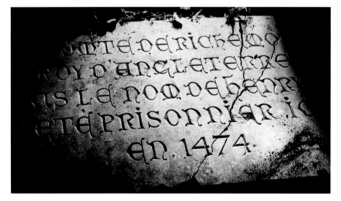

Rieux family in 1463. Marshal Jean de Rieux was a councilor of Duke François II (1433–1488), and then tutor to his daughter, Anne of Brittany (1477–1514). When the king of France, Charles VIII (1470–1498), invaded Brittany during La Guerre Folle, Jean de Rieux took sides with the duchess, Anne, the future queen of France. As a result, all of the marshal's strongholds, including Largoët, were burnt down or razed. Years later, when Anne married Charles VIII, she rewarded Jean's fidelity by permitting him to re-build this castle. How it eventually fell into ruin is a mystery. I asked whether it was haunted; the woman said that the curator told her that he avoids the donjon at night and that a horribly disfigured apparition has been seen near the moat. As we parted she called out, 'One of your kings was a prisoner here, but I can't remember which one.'

I could now see the top of the towers ahead as I passed the ruin of a former chapel, cloaked in ivy. Through the Gothic window the sun lit up a strange cross in the interior, a symbol of salvation against the powers of darkness. A drawbridge, crossing the deep moat surrounding the castle, is adorned with the Rieux coat-of-arms, a horse with the head of a wild boar and the tongue of a wolf. Inside the court are two impressive towers: the smaller, more recent one on the west side serves as a hunting lodge for the present owner and is closed to the public. The imposing donjon on the east side is the highest in France, rising fifty-seven metres above the moat. This is a fairy-tale fortress in a bewitching setting, but something made me hesitant: its detached, almost dispassionate atmosphere should have served as a warning.

In front of the castle runs a river that has been dammed to form a dark lake full of wild plants and algae. If I could

above
Commemorative plaque bearing an inscription attesting to King Henry VII of England's imprisonment here in 1474, Largoët Fortress

facing page
Largoët Fortress

not prevent him from importing sorcerers from all over Europe. Under the influence of the most sadistic of these, Francesco Prelati, he was persuaded that, to succeed in his quest, he must enlist the help of the devil by committing the most abominable crimes. It was then that he discovered the grotesque passion that was to consume him for the rest of his life: the torture, sexual abuse, and murder of young children, most of whom were boys. It is said that more than two hundred were sacrificed in his attempts to commune with Satan. These nightmarish rituals were rumoured to involve the display of severed heads on plates and eyes in phials of blood but, because of his great power and fame as a soldier, no one dared accuse him.

Then, in 1440, Gilles was finally arrested and taken to the city of Nantes, where he made a dramatic confession

before he could be tortured. He was tried, found guilty, and sentenced to death by hanging. Prior to his execution he gave a lengthy sermon to the large crowd on the evils of uncontrolled youth. He admitted his sins and exhorted the gathering to raise their children in a strict manner and to be faithful to the Church. His speech has been lost to history, but the records claim that it was a fine example of Christian humility and repentance that moved many of his audience to tears. After his death, it is said that five young women removed his body from the stake and had it solemnly buried, but his spectre is still said to haunt Tiffauges, and the screams of terrified children have been heard in the dead of night.

In 1847, Gustave Flaubert described Tiffauges as a château that was like a 'deaf and dumb phantom, abandoned, cursed, and filled with savage echoes.' I found that little has changed in a hundred and fifty years. Many of the great walls have collapsed and the main tower is closed to the public, its surrounding moat filled with rubbish. Even the chapel and the atmospheric crypt below have an oppressive, haunting feel. For this is a place 'where no birds sing,' and the horror of this evil man's legacy will surely outlast time.

It has been an unnerving two days: my feelings have ranged from overwhelming distaste and sadness to fascination and incredulity. Tomorrow I travel to one of the most beautiful châteaux on the Loire, Azay-le-Rideau, whose atmosphere and spirits are altogether more ethereal.

above
The Crypt, Tiffauges Château

facing page
Champtocé Château

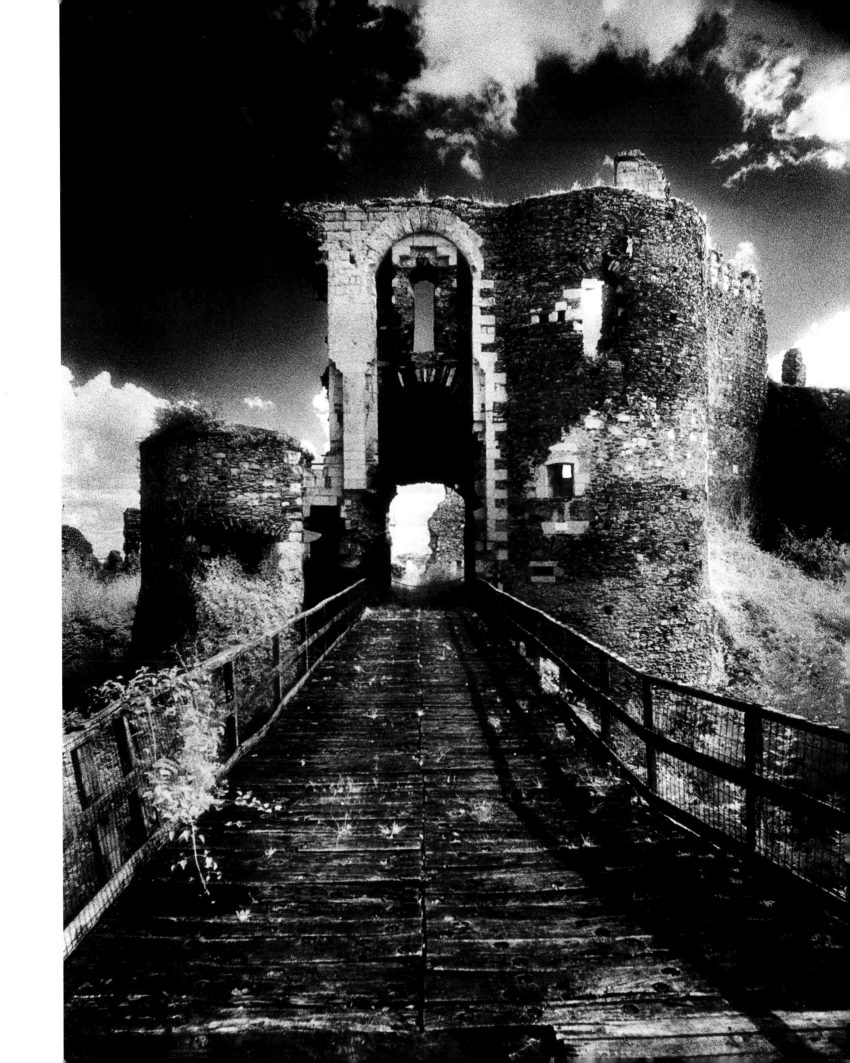

In the Mists of Time
- 5 October -

And travellers now within that valley,
Through the red-litten windows see
Vast forms that move fantastically
To a discordant melody;
While, like a rapid ghastly river,
Through the pale door;
A hideous throng rush out forever,
And laugh but smile no more.

– Edgar Allan Poe, 'The Haunted Palace', 1839

Not the largest or grandest of the Loire châteaux, Azay-le-Rideau is perhaps the most atmospheric. Inside, it is now almost an empty shell, stripped of much of its Renaissance grandeur, but from outside in the evening mist it can appear like a ghost ship passing in the night. The massive, cold stones of its thick walls are imprinted with memories of past glories.

Built on an island in the middle of the river Indre, the mansion is a reconstruction of an earlier fortress, rebuilt according to contemporary tastes. Gilles Berthelot, the son of a master of the chamber of the King's Treasury, acquired the lordship of Azay in 1515. He had made a lucrative marriage and his flourishing career was further helped by his friendship with Jacques de Semblançay, the finance minister. Soon Berthelot became the general tax collector and then treasurer of France; his new château was a worthy expression of his dazzling career. But then disaster struck. His protector, Semblançay, was accused of corruption, locked in the Bastille, and executed in 1527. Berthelot fell under suspicion and was forced to flee, leaving his wife in the unfinished building. Charles de Biencourt completed the château we see today towards the end of the eighteenth century.

According to Peter Underwood, an English writer on the supernatural, in 1418, Charles VII, who was then the dauphin, felt that the Burgundian guard of Azay had insulted him, and with regal arrogance ordered the town to be burnt and the three hundred and fifty soldiers in the castle to be executed. This terrible event seems to have left a shadow over the château, for not only are there unexplained screams and mysterious apparitions seen within the building and grounds, but on certain nights a strange unearthly glow, like flames, rises up from the waters and seems to lick around the base of the castle walls.

Looking through the camera lens, everything seemed unreal. I felt I was capturing an ethereal tapestry of spirits, a mirror image of the past.

facing page
Azay-le-Rideau Château

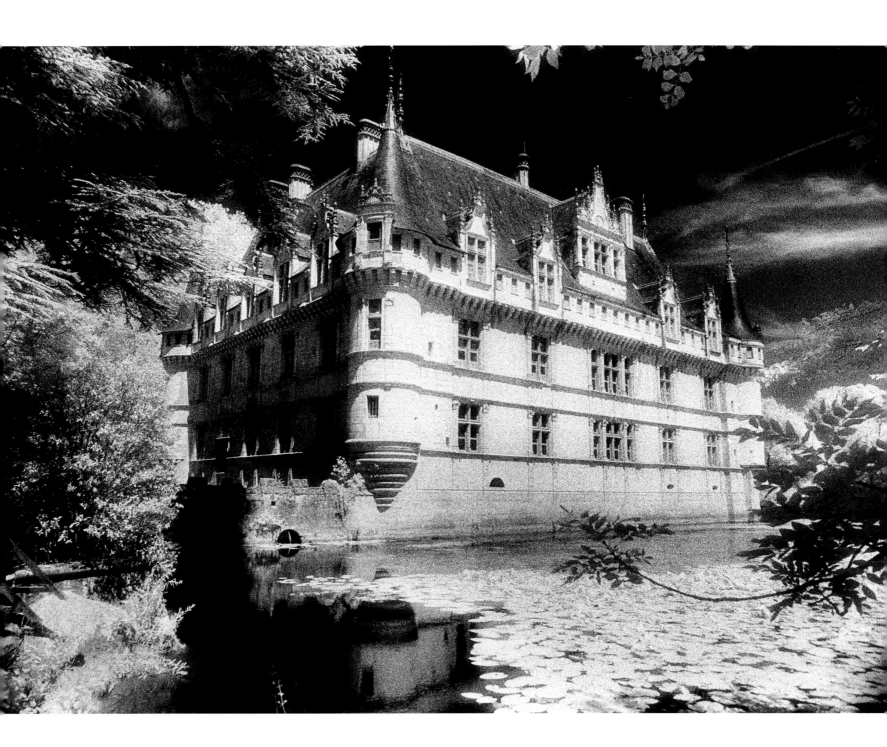

LOIRE VALLEY – CHENONCEAU CHÂTEAU

Spirits of Remorse

- 6 October -

O splendid Paramours, who roam by dark
And in the day lie hidden in your tombs,
Diana, Margaret, Duchesses, Queens,
Dim ghosts of bygone days and Royal Courts,
The night is yours: gallants and poets walk,
Smiling and handsome, proudly at your side.
With chatter gay and simple song, enlaced
Beneath the birches, phantom couples glide.

– André Theuriet, 'Phantoms of the Shadow', in Vivian Rowe, *Châteaux of the Loire*, 1954, p. 12

Of all the châteaux on the Loire, Chenonceau is the most romantic. For it was female passion and fantasy that created this mysterious, motionless wonder that floats on the gentle waters of the river. On a tranquil autumn evening, the hordes of summer tourists long gone, I had all the time in the world to wander through its tapestried halls and ornamental gardens. Here, in the sixteenth century, King Charles IX (1550–1574) would entrance his guests by having his courtiers dress as mermaids, nymphs and satyrs. But it is the personalities of the exceptional women who built and ran Chenonceau that made the estate one of the treasures of the Loire Valley.

Two of these women are said to haunt the slumbering château, which has seen both days of great happiness as well as nights of frightful revelry and debauchery. Diane de Poitiers (1499–1566), mistress of Henry II, was regarded as the most beautiful woman in France in her day. She possessed an extreme intellect and retained a great influence over the king. It is even said that Henry would spend the first part of the night in bed with Diane and then retire upstairs to his wife Catherine de Médicis (1519–1589).

above
Diane de Poitiers, by François Souchon, nineteenth century

facing page
Detail on an urn, Chenonceau Château

On nights of the full moon, Diane's ghost lingers pale and sad before the great mirror of her bedroom. Catherine's ghost can sometimes be seen combing the long hair of her rival, her face contorted by an evil smile. When Henry died, his jealous wife exiled Diane from Chenonceau, but her phantom seems unwilling to leave.

I spoke at length with the chief curator inside the château, who told me how she and her colleagues often heard footsteps in the building when all the visitors had left. They knew no one could be there; they had grown used to it. Interestingly she added that, once a year, the local people, mostly the elderly, would visit the château to touch and listen to the stones of the building. When I asked why, she replied, 'To recharge their spiritual energy.'

She then took me upstairs to show me the room of the tragic sixteenth-century queen, Louise de Lorraine (1550–1601),

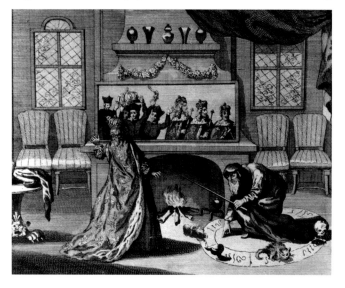

who inherited Chenonceau from Catherine de Médicis. She endured a loveless marriage with her homosexual husband Henry III, who preferred the company of his male acolytes. After his assassination in 1589 at the hands of a monk, she transformed Chenonceau into a tomb. Everything inside was draped in black and the queen roamed through the corridors with an entourage of nuns, dressed in white—the colour of royal mourning. This bedroom is where she spent the last eleven years of her life in the macabre shadow of death, surrounded by funerary symbols of skulls, bones, shovels, and with drops of blood and silver tears painted on the walls. Known as *la Dame Blanche*, her ghost is still sometimes seen watching from one of the château windows, rosary in hand, murmuring prayers for the soul of her errant husband. It was not difficult to feel her presence in the room.

Later I found myself in Diane de Poitiers' garden, where she had devoted herself to creating a paradise for her lover. Here she planted hawthorn and hazel bushes, wild strawberries and violets, even five hundred white mulberry trees for the cultivation of silk worms. But tragedy struck again, as Henry II never lived to inaugurate them: he was fatally wounded in a tournament and died in 1559. His mistress Diane was then forced to hand over the estate to the widowed Queen Catherine, who set about changing everything her predecessor had achieved.

I wandered down one of the avenues beside the canals, stopping to photograph the many female nymphs that adorned the lines of urns, each one as white and ghostly as the hapless Louise de Lorraine. It occurred to me that seldom had so much love and sadness been confined to a single place.

above
Catherine de Médicis' magic mirror

facing page
Chenonceau Château

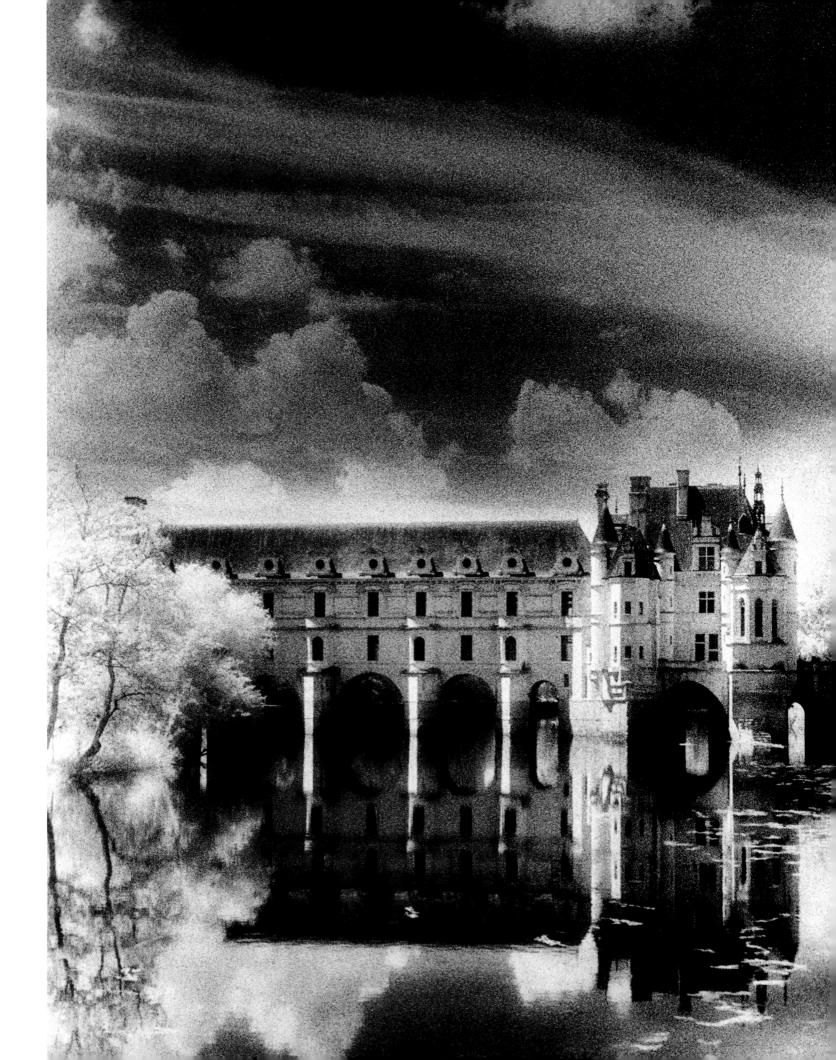

LOIRE VALLEY — LOCHES DONJON
The Dark Tower
- 7–8 October -

My purpose in travelling to Loches was to visit the royal château that towers above this beautiful medieval city. In the fifteenth century Charles VII (1403–1461), then the dauphin, took refuge in this impregnable château during the Hundred Years' War. Joan of Arc (c. 1412–1431) visited him here after her victory at Orleans in 1429, pleading with him to go to Reims and be crowned king. He returned to Loches as monarch, but later betrayed Joan when she was tried and burnt as a witch by the English.

I stayed in a wonderfully atmospheric hotel where very little of the décor has altered since the nineteenth century. Over breakfast, the owner told me to visit the tomb of Agnes Sorel (c. 1422–1450) in the chapel. She had been the mistress of Charles VII—in fact the first 'official' mistress of any French king—and bore Charles three children. A celebrated beauty with a daring fashion sense, she was a controversial figure who made many enemies. A famous portrait of her shows her with her left breast bared. She died at the young age of twenty-eight of a 'flux of the stomach', but many suspected that she had been poisoned. In 2005, more than five centuries after her death, tests on her skull, jaw and hair determined that she was poisoned by an overdose of mercury, but scientists couldn't confirm whether or not she was murdered. Her ghost is said to have been seen in the château and grounds. Her tomb is certainly impressive and, in the darkness of the church, I could almost feel the presence of her spirit returning, as so many apparitions do, unable to rest until the mystery surrounding their death has been resolved.

The castle's infamous donjon, once France's most feared prison, bears an aura of evil. Louis XI (1423–1483) transformed the fortress into a royal jail towards the end of the fifteenth century. Many of its famous prisoners were held in iron cages suspended from the roofs of their cells, known as *fillettes*. Some of these enclosures were so small that the victim was unable to stand up or to lie down inside. They were said to have been designed by Cardinal Jean Balue, who later betrayed the king and was jailed for eleven years in one of his own horrific creations.

Another famous prisoner was a duke of Milan, Ludovic Sforza (1451–1508), also known as 'the Moor', who was captured by Louis XII (1462–1515) and jailed here for eight years. When set free he was unable to cope with the shock of daylight; he collapsed and died almost as soon as he left the castle. No wonder those that live close to the fortress are said to hear ghostly cries and screams in the night. After the horrors of the Revolution, the building remained a state prison until 1926—the suffering and terror of almost five hundred years embedded in the thick stones walls.

One of the castle's guides told me what it was like to work in such an environment. 'I have learnt to blot out these past horrors,' he replied. 'But you are lucky you are experiencing the tower in early autumn. In winter it has another feel—the chill of death.'

above
Fillette (iron cage), Loches Donjon

facing page
Loches Donjon

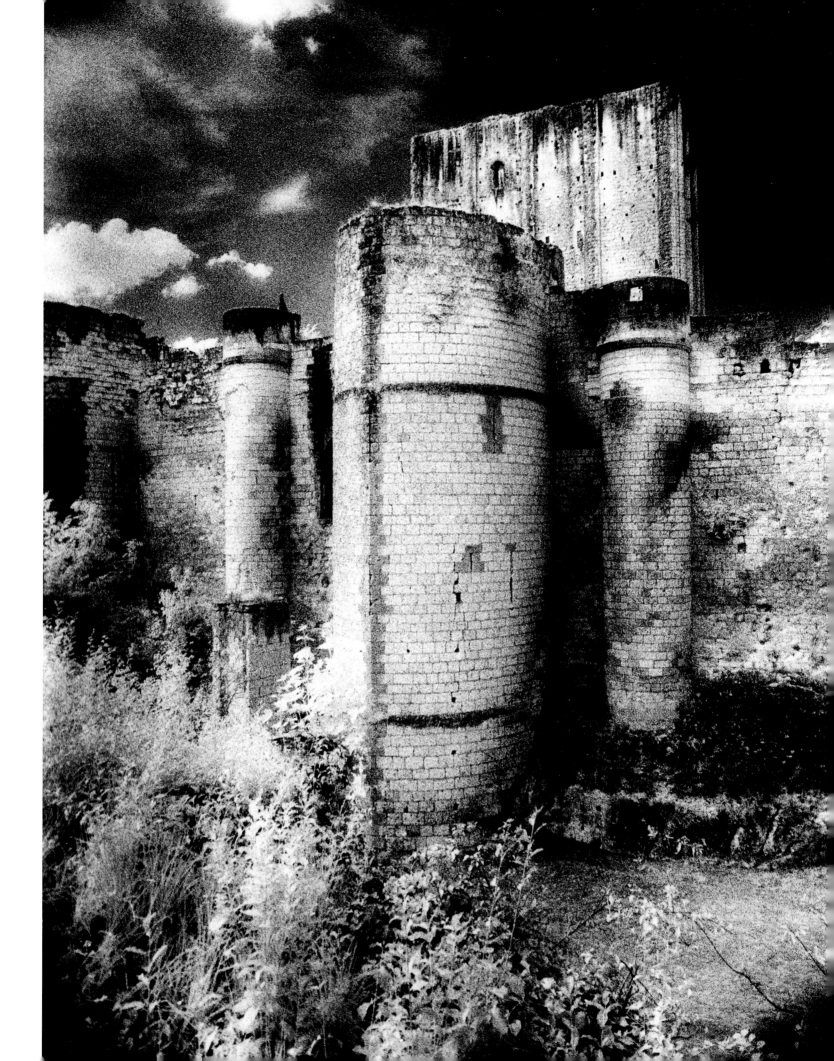

The Lord's Revenge
- 9 October -

The name Meillant comes from the Celtic word *Medialanos*, meaning the Middle Plane, and for centuries this romantic Gothic château has been protected by surrounding forests and swamps. A coat of arms over the main doorway depicts two wild men or savages emerging from the trees, an ancient symbol of strength and sexual virility, and the weathered statue of a Celtic god was recently found in one of the lakes: both are testimony to the castle's mythical and pagan heritage.

Shrouded in mystery, the building is adorned with flamboyant statues and alchemical symbols representing medieval romantic fantasy at its height. Its fifteenth- and sixteenth-century lords, the Amboise family, had important Italian connections; they brought back to France many famous architects, sculptors and designers to build the château we see today. It was Leonardo da Vinci (1452–1519) who drew the plans for the upper part of the Lion Tower. Grotesque gargoyles guard the small family vault in the courtyard of the castle, which was transferred by marriage to the family of Rochechouart de Mortemart in the nineteenth century. They are one of the oldest families in France: Madame de Montespan, the mistress of Louis XIV (1638–1715), was a Mortemart.

Aimery de Mortemart, the present owner, is clearly devoted to his inheritance. He is not frightened of ghosts, but said that his late mother, Jeanne de Mortemart, who lived in the left wing of the château, always said that she heard 'someone' or 'something' knocking on the walls at night, and footsteps on the tower stairs when no one was there. He thinks this might be the ghost of the jealous lover of Charles II of Amboise's mistress. Charles (1473–1511) was besotted by her, and when he heard that she had a lover, who planned to murder her out of jealousy by tightening the bit in her horse's mouth, Charles tricked the man into riding the animal himself. The lover was thrown off and killed—the actual bridle bit can still be seen in the château.

Aimery de Mortemart went on to tell me that the château was full of secret passages and stairways, but that many of the entrances remain locked because the keys have been lost. I was interested by a very peculiar seventeenth-century cupboard in the Louis XII room. If you look at it from different angles you will see the sculptures mysteriously changing in the light. In the Cardinal's Room is a sixteenth-century wooden sculpture of heretic inspiration showing Christ in God's arms

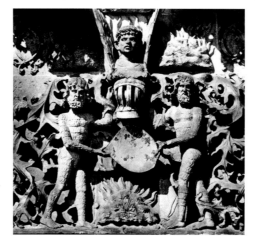

instead of those of the Virgin. If the artist had been caught he would have been burnt alive. At the bottom of a corridor, in front of a window, is a Gallo-Roman stone statue, a Druid, who was for the Gallic people a mediator between the divinities and mankind —and had the power to predict the future. This is a realm of mystery and sorcery where time seems to have stood still. I felt privileged to have been part of this 'lost world' and its arcane lore.

above
Coat-of-arms of the Amboise family, Meillant Château

facing page
Meillant Château

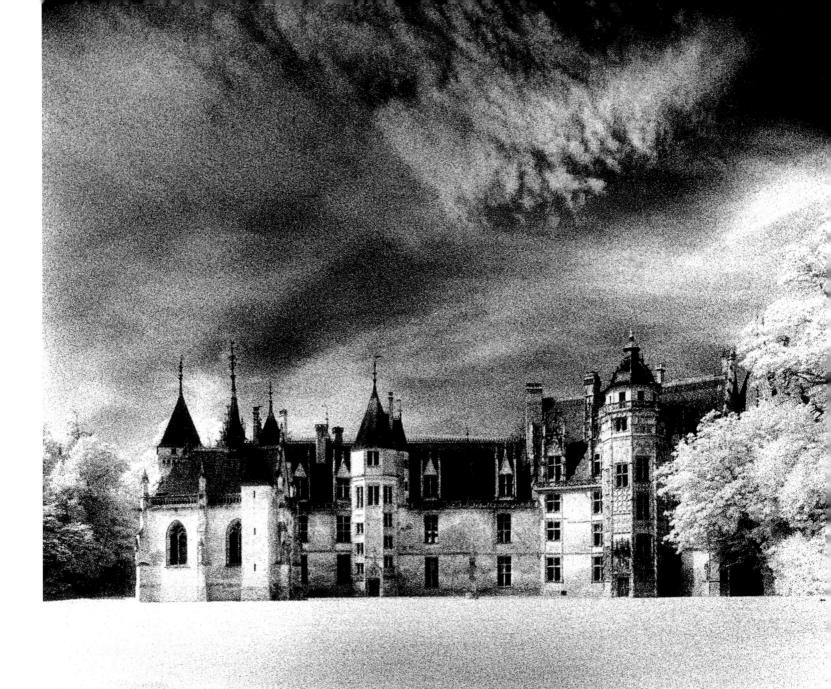

LOIRE VALLEY — AINAY-LE-VIEIL CHÂTEAU

Melusine Revealed

- 10–11 October -

I was not far from the ancient castle of Ainay-le-Vieil; I had been invited by the owners to stay overnight there. Life on the road can become very tedious when one is always staying in hotels, so I was looking forward to some human contact, and seeing what I was told is a magnificent château with a unique history. Most intriguing is the family's ancestral association with the legend of Melusine, a tale that reaches back into the mists of time.

The myth of the mermaid-like creature known as Melusine has its roots in Celtic folklore, and to this day there are many families in France, especially in the Poitou region, who include her figure in their coat-of-arms. There are several versions of the legend, but the most recognized describes Melusine as the daughter of a fairy who married a Scottish king on the condition he would not come into her room when she was giving birth or bathing her three daughters. He disobeyed, though, and they were forced to flee his kingdom forever. When Melusine and her sisters heard the reason why, they returned to imprison their father in a mountain. However, their mother was angry with her children for doing this and put a curse on each of them. Melusine's fate was that once a week she would change from a beautiful girl into a monster, with a snake's tail and bat's wings. The only way to ease the agony of this transformation was to keep wet, to bathe the entire day. Worse still, if she ever got

married and her husband saw her in this terrible form, she would be cursed to remain that way forever.

They moved to France, and one day a French nobleman, Raymond Poitou, came across Melusine in the forest, bathing in a spring. He fell madly in love with her at first sight, begging her to marry him. She agreed, but on one condition: he must leave her alone every Saturday in her tower in the castle, and never, ever spy on her. Raymond was love-struck and readily agreed.

Their marriage was a great success. Her magical powers built them a castle at Lusignan in a single night, and Raymond grew very rich. They had ten sons together and their lives seemed complete. But one of Raymond's jealous knights questioned why Melusine needed to be alone every Saturday night, suggesting to Raymond that she was having a secret affair. At the next opportunity, her suspicious husband hid in her chambers and watched her as she bathed. When he saw her transformed he let out a cry of horror, giving his presence away. With an unearthly scream, Melusine flew out of the tower window, cursed to remain in her monstrous form for evermore.

Legend has it that, from that moment on, whenever a lord of Lusignan, his son or grandson was about to die, Melusine would fly around the tower, wailing her unearthly scream in warning, grief, or both.

above
Melusine, by Émile Bayard, 1884

facing page
Fireplace depicting 'The Legend of Melusine,' Ainay-le-Vieil Château

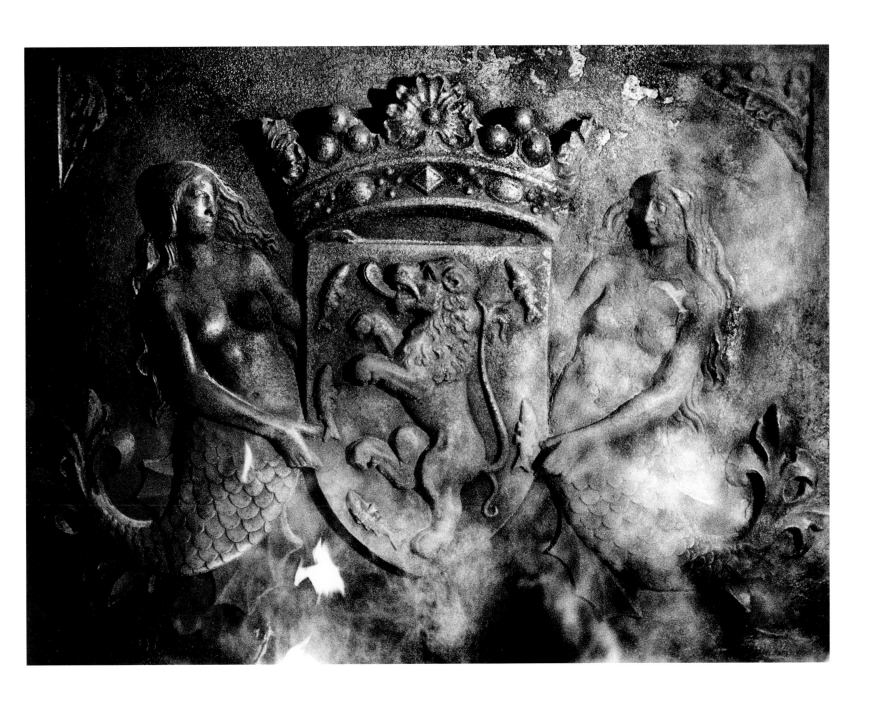

This manifestation has many similarities with the ghostly appearance of the Irish ill-omen, the *Bansidhe* (Banshee), meaning the 'spirit of death', the most weird and awful of all the fairy powers. According to legend, the chilling cries of Melusine only stopped after the castle of Lusignan was razed to the ground. There is a famous medieval painting in the Duc de Berry's *Book of Hours* which shows the Château of Lusignan in the background—if you look closely you will see Melusine in her dragon form, flying over the right-hand tower.

Driving into the courtyard I was greeted by Marie-France de Peyronnet, whose family, the d'Alignys, have owned the castle since 1467. She lives here with her sister and brother, and all three made me feel very welcome, as if I were a long-lost relative. A highly intelligent woman, Marie-France has a great knowledge of her family's history, and we chatted for several hours before she took me on a guided tour of the château and grounds. I photographed the coat of arms over the main entrance of the castle, which includes the figure of Melusine, and above this tower the weather vane in the shape of a dragon. She told me that this had a special meaning for the family, and that tradition decreed that they would be in great danger if it were to be destroyed or lost. She remembered being at a dinner party with other members of her family one very stormy night; as they were driving home they all began to feel very strange and apprehensive, but couldn't understand why. Then, as they approached the castle, they realized that something was wrong: the weather-vane had blown down.

It was now early evening and I was taken up the great stone stairs and shown a room in one of the towers where I would be sleeping. Opening the shutters, I looked out over the moat as the sun was beginning to set. I felt very much at home. Later, as I lay in the old-fashioned bath, I thought I heard a girl singing in a very slow, quiet voice. At dinner, Marie-France's sister, Marie-Sol de la Tour d'Auvergne, joined us. We sat at a large, candlelit table, and again discussed their family history. Several of their ancestors had been guillotined during the Revolution and they felt it their duty to preserve their inheritance as best they could in such uncertain times. They agreed with me that it is the past that has made us all what we are, and how sad it is that in our modern, technological world the past is so often dismissed as irrelevant.

After dinner we sat before an ornamental fireplace that also depicted the legend of Melusine, her mythical figure appearing and disappearing amid the smoke and flames as if by magic. I asked Marie-Sol if she felt the house was haunted. She replied, 'We have lived so long with the many portraits and statues of our ancestors that we have come to feel that they are real people. I suppose you could call them ghosts.'

Later that night, I lay in my four-poster bed thinking of what Marie-Sol had said. It is an interesting thought. Perhaps we all have the inherent power to bring the past back to life?

facing page
Ainay-le-Vieil Château

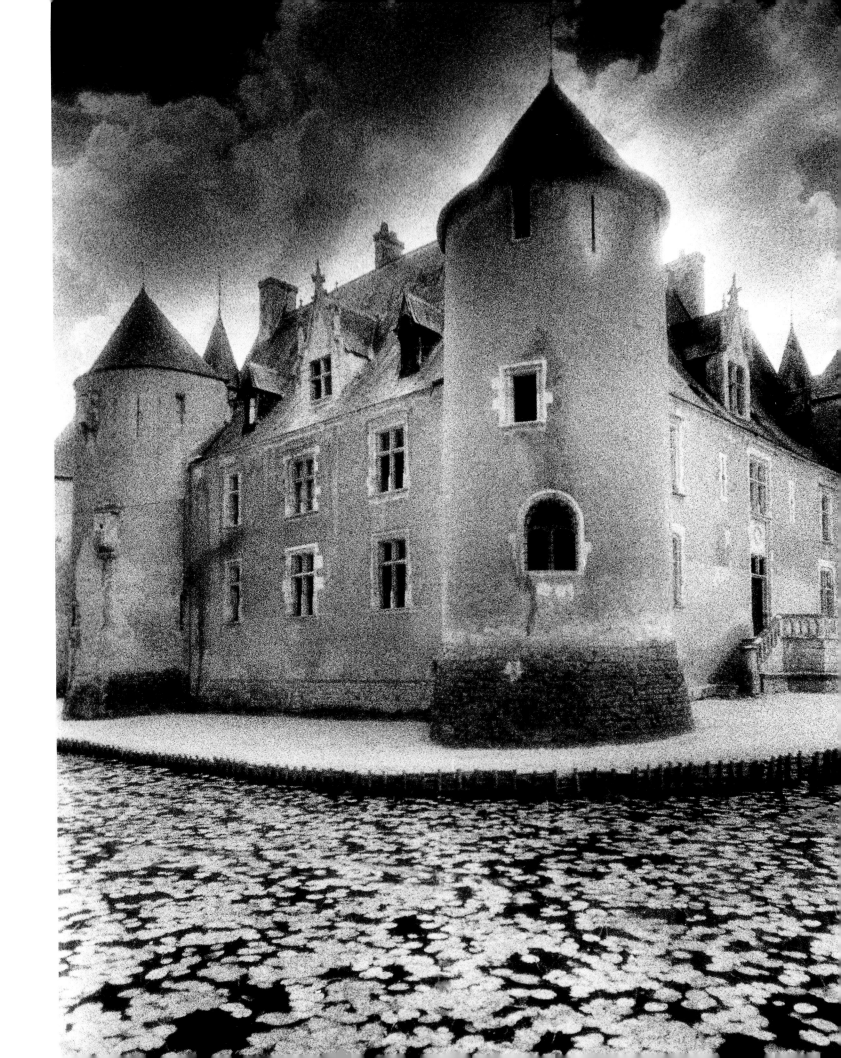

BURGUNDY AND LYON — CHASTENAY CHÂTEAU AND SAINTE-MADELEINE BASILICA, VÉZELAY

Secrets of the Alchemists

- 12–13 October -

Today seems unusually hot for mid-autumn. Driving towards the hamlet of Val-Sainte-Marie, I began to sense that this was an ancient, magical landscape. At the château, the official guide described how the castle had been in the same bloodline since 1086. The present incumbent, Count de la Varende, is a descendant of its founder, Gibaud d'Arcy, a member of the Knights Templars. The count is also a descendant of André de Montbard, one of the original nine Templars who founded the order in Jerusalem (see Gisors Fortress, pages 52–57). After the suppression of the Templars in 1306, it passed to the alchemist, Jean du Lys, who built the main part of the mansion.

The 'Companions of the Builders of Jerusalem' sited it over a deep cave that contains a lake, using the same ancient knowledge that they had transmitted in the building of the Gothic cathedrals (see Chartres Cathedral, pages 36–37). They used the principle of 'Divine Proportion', in the belief that everything in the universe could be described in terms of numbers, and that there was a direct correspondence between the panorama of stars and planets and events here on earth. They believed that this arcane knowledge was deep within our subconscious and held the universe together. The ancient Egyptians also used this principle in the building of the Great Pyramids, as did the Greeks in the construction of the Parthenon. Later, artists such as Leonardo da Vinci (1452– 1519) utilized it in their paintings.

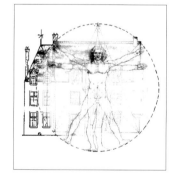

Chastenay, my guide said, is one of the high places of alchemy, and she explained some of the principles of *La Recherche de la Grande Oeuvre*. The number three, the Trinity, is very important in alchemy, and the colours black, white, and red symbolize the three steps to achieving the philosopher's stone, the secret of eternal life. Black (*nigredo*) is the adept's research of the great secrets of the world, white (*albedo*) stands for meditation, research into the inner self and finally red (*rubedo*) symbolizes the rising up to perfection, the mystic union of the soul and body. This is portrayed in the main tower of the building, Saint Jean Tower, where the ground floor is the apprentice's room, the second floor the companion's room and the third floor the master's laboratory. In this room there is a small window on the left side; once a year, on 21 June, the solstice, a ray of sunlight ignites a flame in the fireplace. Interestingly both Gisors Fortress (see pages 52–57) and Montségur Château (see pages 164–173) are said to have similar windows.

As we approached the tower, she pointed out the beautiful busts and symbolic carvings over the doorway. The three steps leading to the door also represent the three degrees of knowledge. The scallop shell reminds us that the pilgrims

stopped overnight at the castle on their way to the basilica at Vézelay. The bust in the centre is Jean du Lys and the gold chain around his neck signifies that he has achieved the 'Great Work'. On the right is Nicholas Flamel (1330–c. 1417), the

above, left
An overlay of Leonardo da Vinci's *Vitruvian Man* on top of the Chastenay Château shows their shared principles of Divine Proportion

above, right
Busts of Jean du Lys (centre), Nicholas Flamel (right) and an unknown alchemist (left)

facing page
Chastenay Château

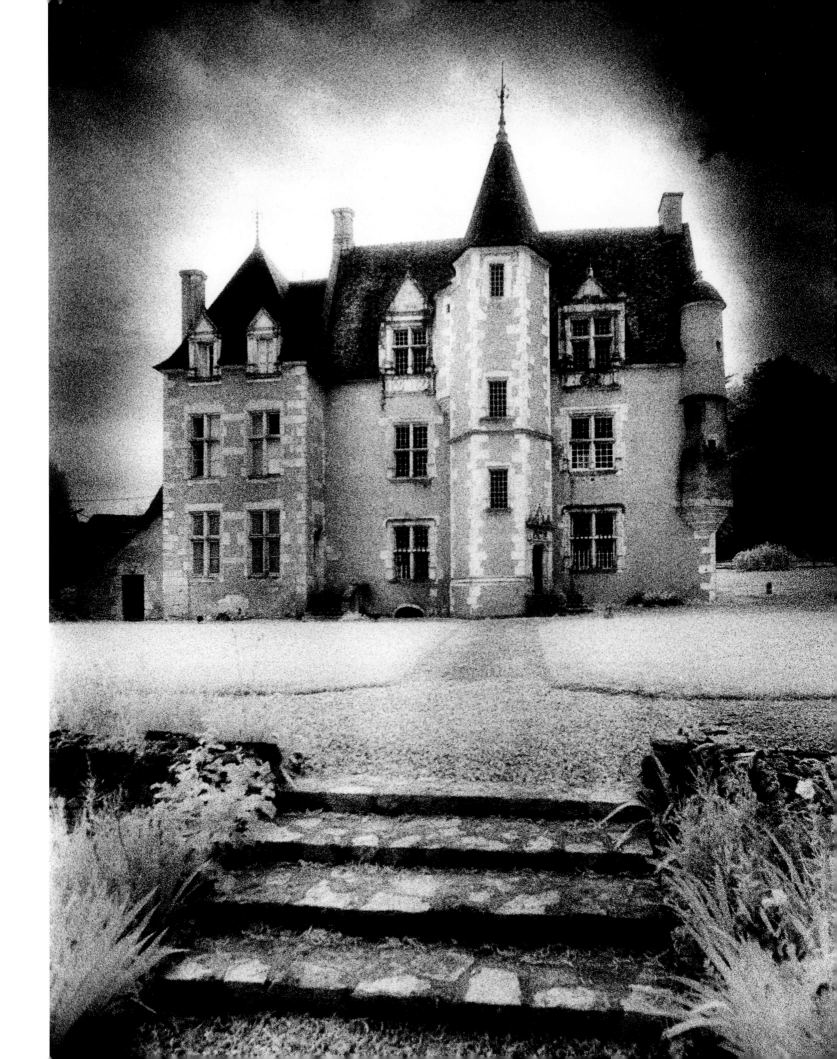

legendary French alchemist who is said to have lived to an exceptional age (pages 36–37). He appeared to become fabulously wealthy through the practice, and when, on his supposed death in 1417, a mob attacked his house, they found his tomb—and that of his wife—empty. On the left is a naked man whose identity is not known for sure, but who is believed to have initiated Flamel into alchemy.

In my wildest dreams I had never expected to find so many wonders in one place. It was now mid-afternoon so we agreed that I would return the next day, to meet the owner.

I have time to visit the great basilica in Vézelay, named after Mary Magdalene—in the thirteenth century it claimed to hold her bones. Her skull is in the church at Saint-Maximin-la-Sainte-Baume in Provence. One of her ribs, from the treasure of Sens Cathedral, is venerated today. Legend says that, after the Crucifixion, Mary Magdalene—along with the Virgin Mary's sister, and Mary the mother of the apostles James and John—fled from persecution in the Holy Land. Together with their servant Sarah, Martha (see Tarascon Château, pages 176–177) and Lazarus, they landed by boat in the Camargue. The event is celebrated every year by the gypsies: they identify with Sarah, said to have been Ethiopian and dark-skinned. Some say that it was Sarah who gave rise to the cult of the Black Virgin (see Chartres Cathedral, pages 36–37).

Mary Magdalene is believed to have travelled inland to Sainte-Baume, where she lived as a hermit in a cave, only venturing down to the plain below when she felt death approaching. There is, of course, another theory, popularized by *The Da Vinci Code*, which says that Mary Magdalene was not a reformed prostitute as depicted in the Bible, but of royal blood and married to Jesus, that she bore him a child whom she brought to France, and that their descendants, through the early Merovingian kings of France, walk among us today—a truth said to have been suppressed by the Catholic Church.

When I entered the abbey I felt the haunting echoes of this lost cult of the 'sacred feminine'. The interior was dark, lit only by candlelight, and I sat in one of the ancient pews to reflect. It was here that Saint Bernard of Clairvaux, a founder and prominent leader of the Knights Templars, preached the Second Crusade to the Holy Land. His speech so moved King Louis VII (c. 1120–1180) and his wife Eleanor of Aquitaine (c. 1122–1204) that they vowed there and then to join. Later, I booked myself into a hotel for the night, and took the time to catch up with this diary.

The sun was shining again as I passed the prehistoric caves at Arcy-sur-Cure on my way back to Chastenay the following day. They contain some of the very oldest cave paintings in Europe and it is rumoured that they are connected to the château by secret tunnels. The count was waiting by the main doorway of the Saint Jean Tower. A very distinguished figure, his eyes are hypnotic and, despite his age and obvious illness, his whole demeanour is that of a much younger man. Having survived the horrors of a Japanese prisoner-of-war camp during World War II, he now has the expression of someone who has achieved an inner peace, a higher level of existence. He says he has always found his home magical, an inspiration, and this has influenced his writing—he is the author of many authoritative books on alchemy and the Templars, speaking frequently about the 'transference of a great knowledge'.

Later we discussed the question of ghosts. He said that here he felt the presence of spirits all around him, but he has no fear of them, why should he? He told me he had recently been talking to two visitors inside the château who suddenly turned pale with fear. They said they had seen a woman in medieval dress appear behind him and then fade away. He looked at me with a piercing stare and said, 'I believed them. They saw her with their own eyes.'

facing page
Figures on a capital in the Sainte-Madeleine Basilica

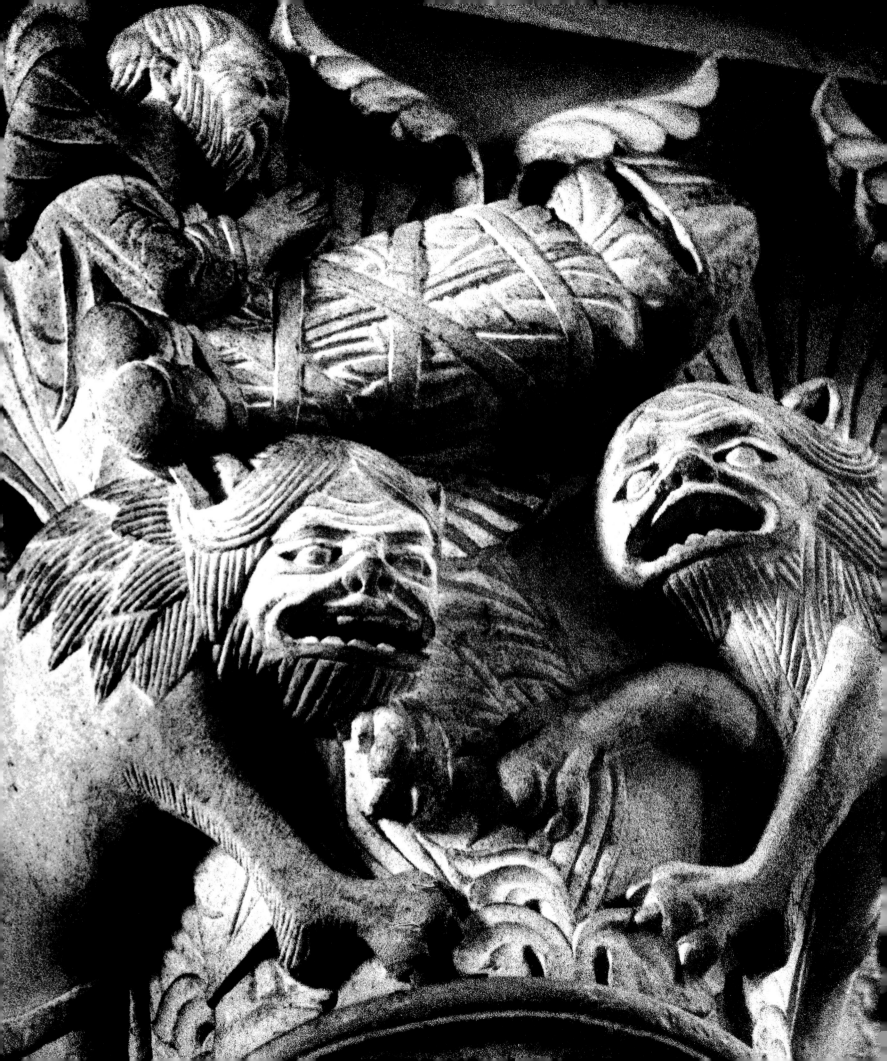

Ancient Powers

- 14 October -

The beautiful French city of Autun was once known as the 'sister and rival of Rome'. It lies surrounded by many reminders of its glorious past, and it was as I climbed the steps of the amphitheatre that I first caught sight of a mysterious pyramid on the summit of an adjacent hill. At first glance it seemed to be nothing more than a pile of stones, but its shape and prominent position suggested something more, and I hurried back to my car. Following the narrow and twisting country roads, I soon found myself in the small, ancient village of Couhard, where I parked my car near the church.

As I began walking towards the curious monument, there was not a person in sight. The grass was overgrown and the area near the stones sadly defaced by the debris of modern-day man. The pyramid itself is about forty feet high, made of irregular stones cemented together. In the middle is a recess that now lies empty. I spent about an hour taking photographs. I had the strangest feeling that someone was watching me, but all I saw were several dead birds and the outline of a dog or large cat lurking in the nearby bushes.

I was convinced that this must be some kind of important death monument, but built by whom, and for whom? Perhaps the church would provide a clue. Just as I was about to enter, a middle-aged man approached me. I asked him what he knew of the origins of the pyramid, and he told me that the pyramid stands on the summit of a very ancient cemetery known as the Field of Urns, and there is universal agreement that it is an important tomb or funeral monument that dates from Roman times or even before then. However, archaeologists and scientists can agree on little else, despite the numerous excavations that have been carried out over the years.

Tradition has it that the pyramid was once sixty feet high, covered with shining marble encrusted with black stars. A twisting stairway led to the summit, and on certain ceremonial occasions a bronze urn containing a chieftain's ashes was displayed in the cavity. There are also numerous theories as to who exactly was buried or commemorated here. Ancient chronicles favour two possibilities: either an eminent king of the Gauls, or Diviciacus, a Gaelic chieftain who was a Druid and a friend of both Julius Caesar and the Roman orator and statesman Cicero.

My companion believed it was Diviciacus. 'This Diviciacus claimed to have the powerful knowledge of nature,' he said, 'and was recognized as a magician and soothsayer by his people. The Celtic doctrine also professed a belief in the immortality of the soul, which could transmigrate into all living things, including animals and birds.'

The man then lowered his voice and spoke of a strange 'force' or 'energy' that was believed to surround the pyramid, and of occasions when unsuspecting visitors or passersby had been rooted to the spot by it. Other stories tell of a strange shape, neither human nor animal, that has been seen in the vicinity of the stones and is said to guard the monument.

facing page
Couhard Pyramid

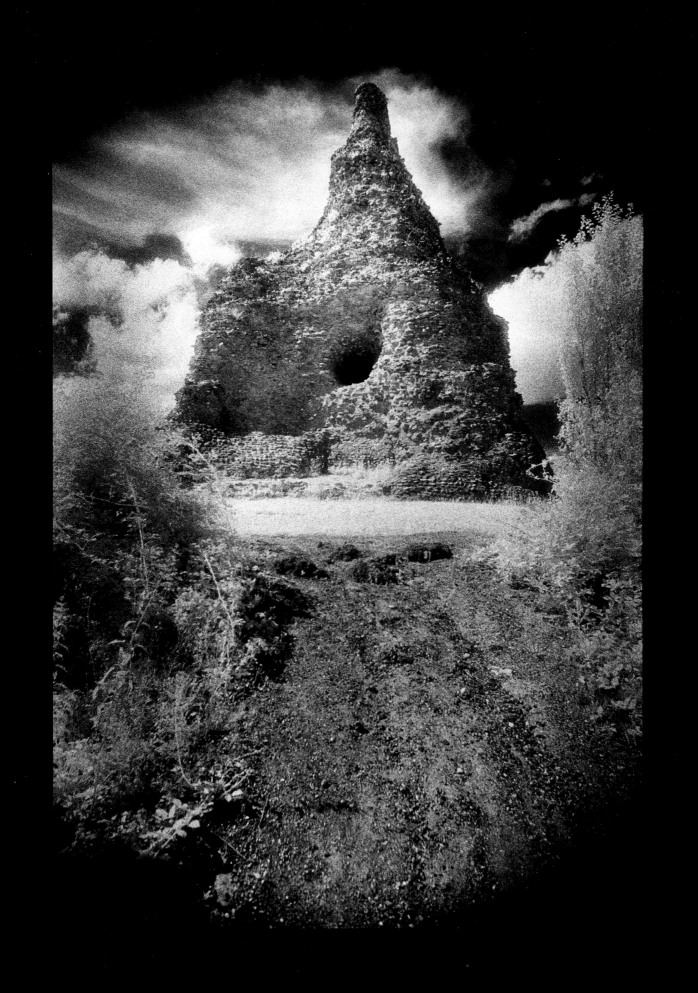

The Hidden Cadavers
- 15 October -

When I first announced on my website that I was compiling this book, I asked if anyone knew of any haunted sites in France that might be of interest to me. One of the first replies was from an Englishwoman who, as an eleven-year-old girl, had stayed for the summer with a French family and remembered being taken to see some hideous but miraculously preserved cadavers in a church crypt in Saint-Bonnet-le-Château.

Parking my car now in a small square, I followed the narrow medieval streets up towards the ancient church, the steep climb made more hazardous by the slippery cobblestones. Then I saw on the summit the dark, ominous silhouette of the church, resembling a set from a Gothic horror film. The guide, a young girl, was waiting at the entrance and, as I was the only visitor, we began a tour of the candlelit interior straight away. She first took me to a beautiful side chapel, which contains exquisite murals that were a present from the duke of Bourbon to his wife; this is said to be one of the fifteen most important medieval sites in France.

As we re-entered the main church, my guide led me to a trapdoor in the stone floor. 'These bodies were discovered by accident during renovation work in the nineteenth century,' she almost whispered as we climbed down a ladder into a small room that smelt of damp. In the dim light I could see that cadavers of all sizes, some standing upright, some leaning at various angles, were surrounding us in what seemed like a cell. She told me that originally there had been thirty skeletons, but now there were only twenty-two. Bizarrely, all their mouths are wide open, as if expressing fright, and some have holes in their breasts suggesting they might have been stabbed. She said that the stone in this district contains two minerals, alum and arsenic, which absorb all the water in a dead body. This is why they have not disintegrated, and the skin has become like leather.

But who, I asked, were they? She said that there are two theories. Some say they are Catholics, who were imprisoned here and left to starve during the religious wars of the sixteenth century by the Protestant baron, des Adrets. But scientists say that they died in the seventeenth century. Another theory is that they are the bodies of a local giant, the lord of Prunerie, and his family, who had bought a vault in the church. There is documentary evidence of his existence, and one of the cadavers is notably taller than the others.

My guide had to begin another tour, and left me taking pictures: I remained in the confines of the crypt another twenty minutes or so. It is always unnerving to be in the presence of the dead, and I admit to being relieved as I climbed the ladder and closed the trapdoor behind me. Before leaving the church I asked my guide whether there were any more crypts under the church. She showed me several more sealed entrances. A network of caves runs beneath the building, but the villagers feel that it would be a profanity to open any more of these tunnels. I asked how she felt about her job. 'I prefer showing people the murals,' she replied, 'but I realize that everyone is fascinated by death.'

facing page
Cadavers, Collégiale Church

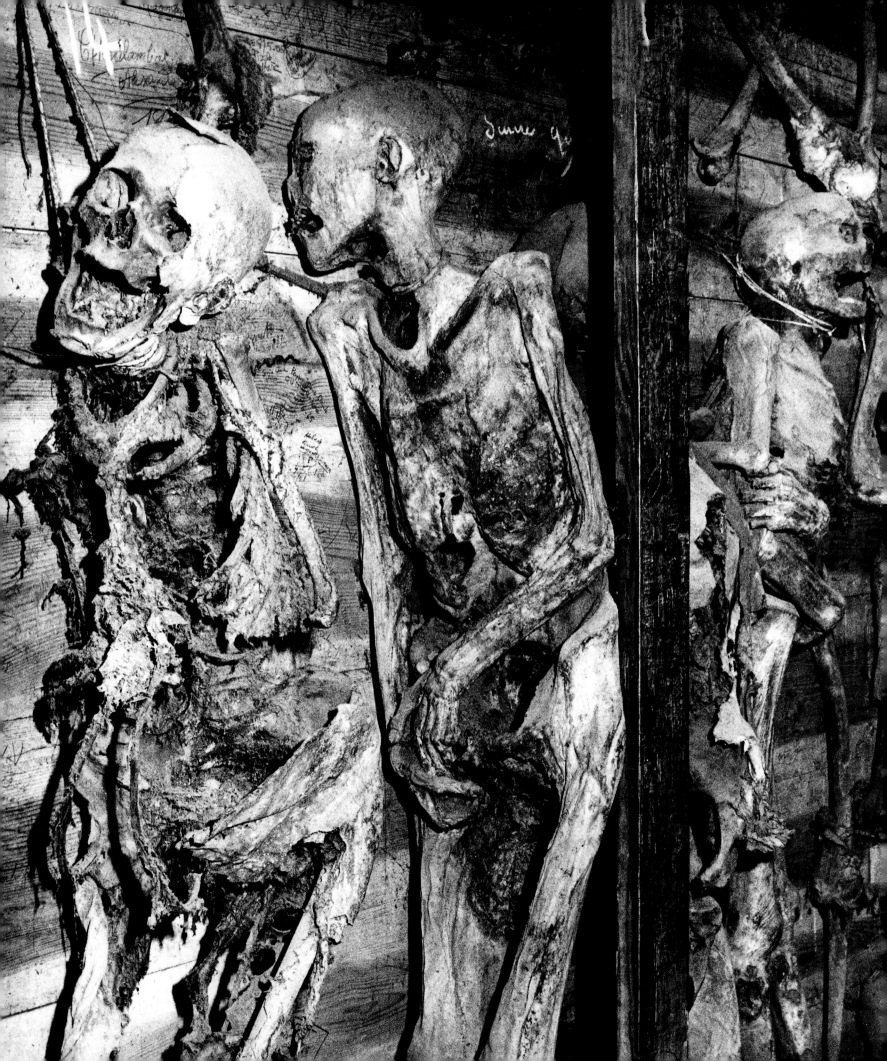

AUVERGNE — VIVEROLS CHÂTEAU

Obsessed by Death

- 16 October -

Perched on a hill high above the village, the impressive ruins of the old castle of Viverols can be seen from far away. Many of the original towers and walls now lie in ruins, but it would seem that a local builder has taken on the Herculean task of renovating it. As I climbed the hill, rain was cascading down the steps; however, as I reached the summit, the sky cleared, leaving a low hanging mist that gave the building an air of desolation.

Loading my camera, I advanced towards the gates of the castle and tried to turn the handle on the door, but it would not open. Looking through the keyhole, I could see piles of stones and what looked like the entrance to a tunnel, but little else.

This château is said to be the most important relic of feudal architecture in the region of Ambert. It is also the inspiration for some disturbing ghost stories. In the nineteenth century, the guards would often be woken in the middle of the night by a fierce, loud knocking on the main gates. On opening them they would always find a distressed old man wearing red, begging to see his master, and then disappearing. Interestingly, his clothes suggested he came from the sixteenth century, but who he was and why he asked the question, no one knows. His forlorn ghost is still said to wander the ramparts today.

In the town of Viverols, there was once a brotherhood of White Penitents, called the Gonfalon Society, who were one of the last of these sects to disappear in 1915. On the same evening every year, they would file through the village wearing their ghostly white hoods, carrying flaming torches and religious banners. They would then turn up towards the château and, as they passed the entrance to the donjon, an apparition, also dressed in white, would mysteriously emerge on top of the tower. This was said to be the ghost of an infamous former lord of the castle, and this public appearance was his eternal punishment for his many evil deeds. His apparition only disappeared as the procession descended the hill.

I was keen to find out more about the castle's history, so I headed for the small tourist office in the middle of the village square. It was closed for lunch, so I went into a nearby bar to pass the time until it reopened. The owner and I began to chat. He knew very little about the castle, but he did ask if I had come across the extraordinary story of Hector Granet. When I said no, his face lit up with excitement. 'It's the strangest story you have ever heard,' he said. 'This man built a mausoleum for his father with a glass window in it, and when the old man died, he embalmed the body in alcohol and placed it inside. He revisited it every day for forty years,

tapping on the glass so that the corpse would float to the surface and he could talk to it!' As he finished, I saw a woman unlocking the door of the tourist office. The bar-owner pointed at her saying, 'If you want to know more, ask that lady. She knows everything about Viverols and Hector.'

I spent two fascinating hours talking to the woman. She gave me a book that had been published on Hector, and rang the mayor's office to see if I could visit his family home on the square. The mayor sent

above
Hector Granet, known as 'The Original', standing in the doorway, with visitors

facing page
Entrance gates, Viverols Château

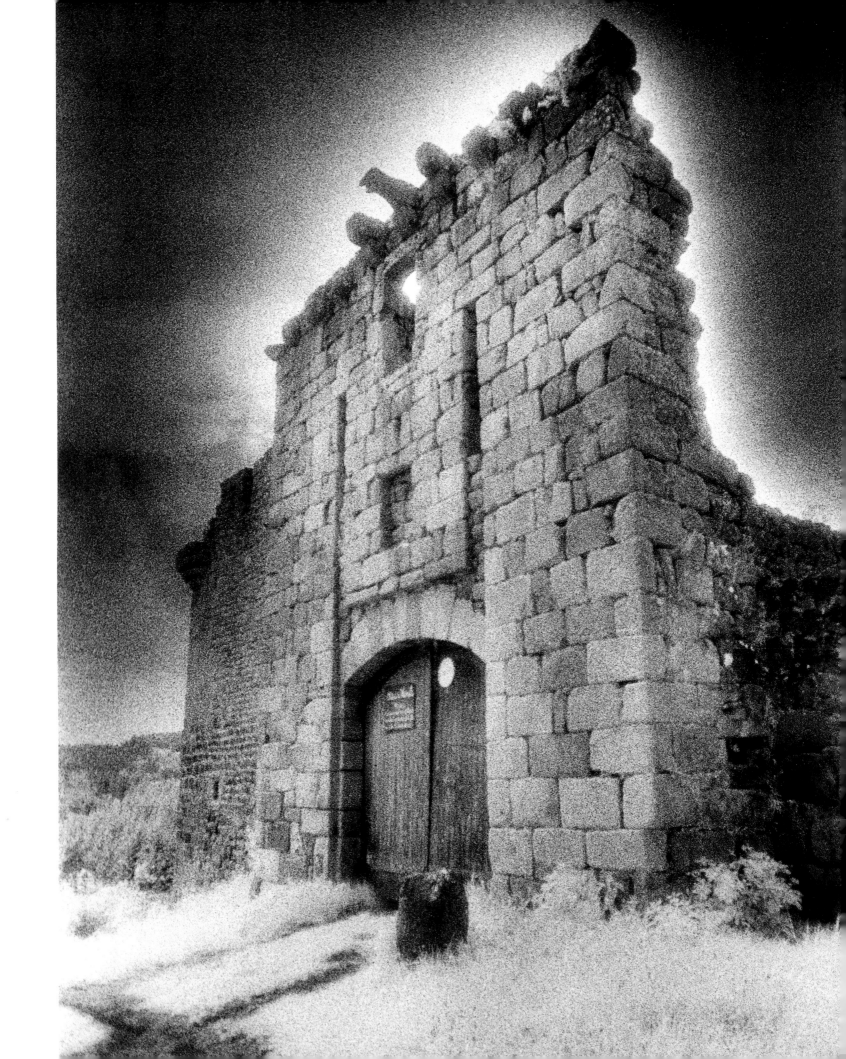

his assistant, who spoke some English. The first floor of the house is now a crafts centre. With some difficulty, we managed to climb a dilapidated staircase to the other floors, which were very dark and smelt of damp. My guide told me that there was only enough money to mend the roof. It was once decorated and furnished in First Empire style, but time and neglect have taken their toll. One room in particular caught my eye, filled with many strange artifacts, church statues and a bronze eagle. Apparently they had been taken from the Church after the Revolution, but were now sadly covered in dust and bird-droppings. Some of the rooms had particularly sinister portraits in them, but he had no idea who they depicted. The whole building had an unsettling atmosphere, as if something very unusual had taken place within its faded walls. Later, we made our way by car to the old graveyard, to see what is left of the chapel and tomb. My guide told me that there was very little to see now and that he hadn't been there for eight years. To my dismay we found the door locked and he had no idea who might have the key.

Later that night, alone in my hotel room, I read the book on Hector that I had been given. It appeared that his mother had been a gentle but weak character and that he had always been very close to his father. At the age of twenty-three, he had become a solicitor, and at thirty-five a justice of the peace. Never marrying, he lived at home with his parents until he buried them. After the death of his mother in 1870, he and his father became almost inseparable. Together they built an isolated mausoleum and chapel on the outskirts of Viverols, with a round tower and a trapdoor leading to an underground room. Here they put his mother's ashes in a zinc tomb. In the space above her they built two more zinc coffins for themselves, and prepared embalming oils and perfumed alcohol to preserve their own bodies when they died. After the death of his father at the age of ninety, Hector visited his tomb every day, sometimes alone, sometimes with friends. Curious strangers began to visit as well, to glimpse the floating body through a porthole; they enjoyed tapping on the glass and watching it jump up like a marionette and stare at them. Often Hector would sit beside the tomb playing his father's favourite tunes on the accordion.

His father had kept extensive diaries, and there are many references to Hector's interest in spirits and the afterlife. At a very young age he wrote a poem titled '*Les Revenants*' ('The Ghosts'), and would act out plays with a similar theme. During his lifetime it was known that he tried to contact the dead, but we will never know if he succeeded. As Hector grew older, he became a recluse in the family home, surrounded by a colony of cats and a mass of legal documents. He created a museum in the tower of the funeral chapel above the tombs, containing many mysterious objets d'art and ancient manuscripts. On his death he was reunited with his parents in the bizarre sarcophagus he had prepared for himself. A few years later, the museum was closed and the chapel walled in. But there are those that claim to have seen his ghost, wearing strange hats and carrying a walking cane, still making the daily pilgrimage between his home and the tomb.

Sometimes truth really can be stranger than fiction. But trying to separate the two in Viverols would seem impossible.

facing page
Viverols Château

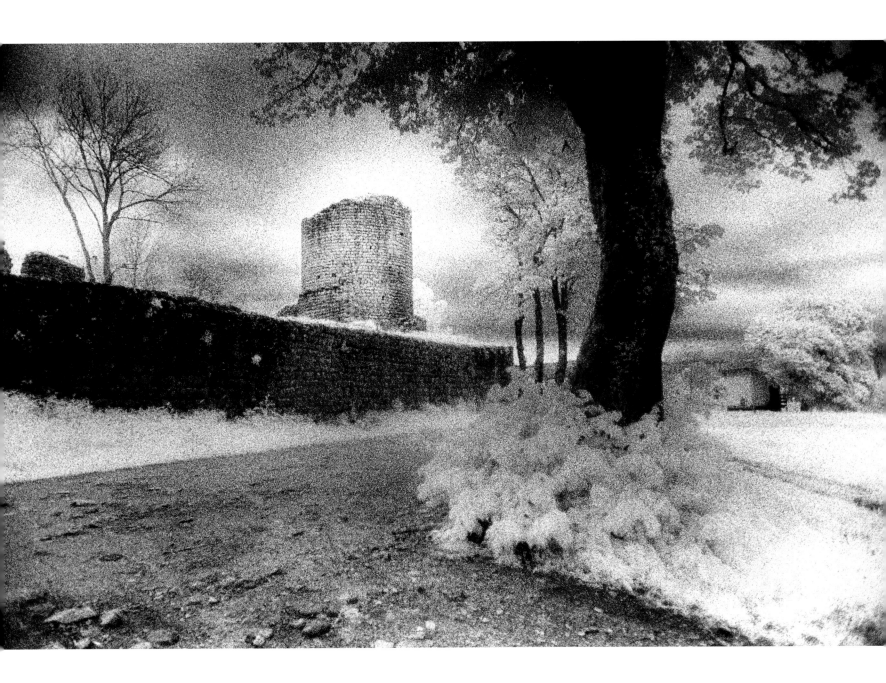

AUVERGNE — RANDAN CHÂTEAU

Déjà-Vu
- 17–18 October -

Today I drove through some beautiful countryside heading towards the north of Auvergne, away from the mountains. At a small village called Randan, I noticed a group of young children in fancy dress, who proceeded through some large, ornate iron gates into a park. Intrigued, I followed them in, parking my car next to a row of buses. Some kind of festival was evidently underway, with a large number of local schools taking part—there were harassed teachers and excited children everywhere.

I walked past them, further into the vast estate, and noticed an obelisk in the distance. Sensing that there must be a château nearby, I walked faster until I could just make out the sad, gaunt shell of a building. The high chimneys and crumbling walls gave the scene a distinctly ghostly aspect. I was overcome by an overwhelming feeling of déjà-vu. Feeling faint I sat down to regain my composure.

After a while I managed to take some pictures, but all the time I felt afraid. None of this made sense. I desperately needed to know something about the château. On my way out of the park I found a teacher preparing a picnic; he told me all he knew of the mansion. Women, he said, had played a great part in its history. The building was begun in the sixteenth century by Fulvia Pico della Mirandola, the sister of the Italian Renaissance philosopher, and continued by Catherine de la Rochefoucauld. The spirit of Adélaïde d'Orléans (1777–1847), the sister of King Louis-Philippe, extended and renovated the château at the beginning of the nineteenth century, entrusting the work to Pierre François Fontaine (1762–1853). In 1925 a

great fire, started by a cigarette left carelessly burning, destroyed it in a few hours.

The house had been celebrated for its underground dining room and massive kitchens—so vast and so well designed, it is said, that aromas could not intermingle and so spoil other flavours. It is also believed to be where praline was invented to satisfy the gourmand appetite of the Duke of Plessis-Praslin, who lived here in the seventeenth century. That was all my informant knew about the château.

I found a hotel in the town and had a few hours of sleep before dinner, but my dreams were disturbing, full of characters and places that I didn't know. Dinner was exceptional and I made sure that I drank enough wine to put me soundly to sleep. In the morning, when I came to pay the bill, I asked the hotel owner what she knew about the château. She produced an old catalogue of the sale of the house contents that she said might tell me something. I sat down to read it, but after a few pages handed it back, thanked her and left. Almost every piece of furniture, every picture, every statue in the brochure seemed familiar.

None of this is making any sense. I have never been here before or set foot in the château. How could I have done? It burnt down before I was born. Could I have visited in another lifetime? I'm not convinced; there might be another explanation. Is it possible that we can inherit our ancestor's memory? This might explain the feeling that we have been somewhere before when we know we have not. Could a forebear's memory have been handed down to be stored in mine like a roll of old film? I must check if any of my ancestors had French connections.

facing page
Randan Château

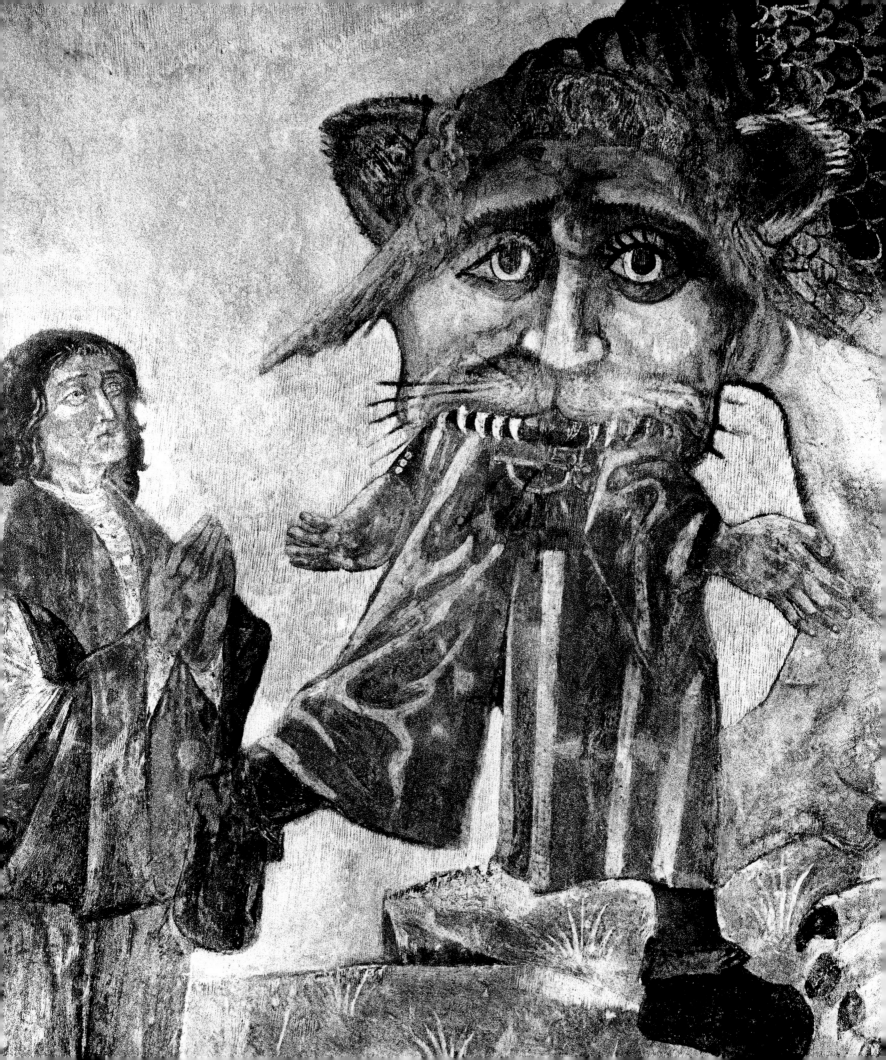

Wintered Evil

- 23 October -

Abandoned at the end of the eighteenth century, these sinister ruins and their many dark secrets overshadow the medieval village of Apchon. The scene of violent conflicts over the centuries, the wicked deeds of its masters—of treachery, murder and debauchery—are legendary. One of their number was described as being 'almost a king but deserving to be hung'. The castle can be seen from far away: high and isolated, it rests on a pinnacle of dark basalt rock. Its elevated position reflects the haughty disdain of its lords, who claimed descent from the Romans, and bowed to no man unless forced to do so.

Their lordship is one of the oldest in the Auvergne. The first of their line was Amblard d'Apchon, the lord of Aubière, who died in 1008, and whose nickname was *Mal Hiverné* (Wintered Evil). He raped a nun, and to punish him for this sacrilege, the king ordered the confiscation of another of his castles at Hauteclair, giving it to a fellow knight, Guillaume Brunet. In revenge Amblard killed Guillaume with an axe, but later felt remorse and went to Rome to be absolved of his sins. Pope Gerbert forgave him; to make amends Amblard gave some of his lands to the monks of Cluny. This story is illustrated on the family's coat of arms, which features a cross topped by two besants, or gold coins, with a battle-axe on one side and a nun on the other.

Below the castle is a meadow known as 'the meadow of war', where a dreadful battle took place during the Hundred Years' War. No quarter was given and there were many dead on both the English and French sides. This is a dark, ominous domain, and it is said that on certain moonlit nights the wraith-like spectre of a young woman can be seen descending from the crumbling towers of the castle, down the hill towards the gates of the old cemetery. Her long white dress is spattered with blood; her emaciated face, a portrait of sorrow. Who she is or why she is there will never be known.

Through the camera lens, silhouetted by two trees, the château reminds me of a painting by the romantic nineteenth-century German artist, Caspar David Friedrich. A local farmer stops to talk with me and I asks him if he knew anything about the lords of Apchon. He seems surprised by my question, saying, 'That was all a very, very long time ago. I imagine they were a law unto themselves and are best forgotten.' I go on to ask him whether he thinks the castle is haunted. 'I have heard the stories,' he replies. 'There are many unexplained phenomena in the Auvergne. This is a remote, wild region where supernatural beliefs still persist.'

Tomorrow I shall drive through the Cantal Mountains to the ancient town of Salers, where I am told I will find an old residence that was used by the Knights Templars in their secret initiation ceremonies.

facing page
Apchon Château

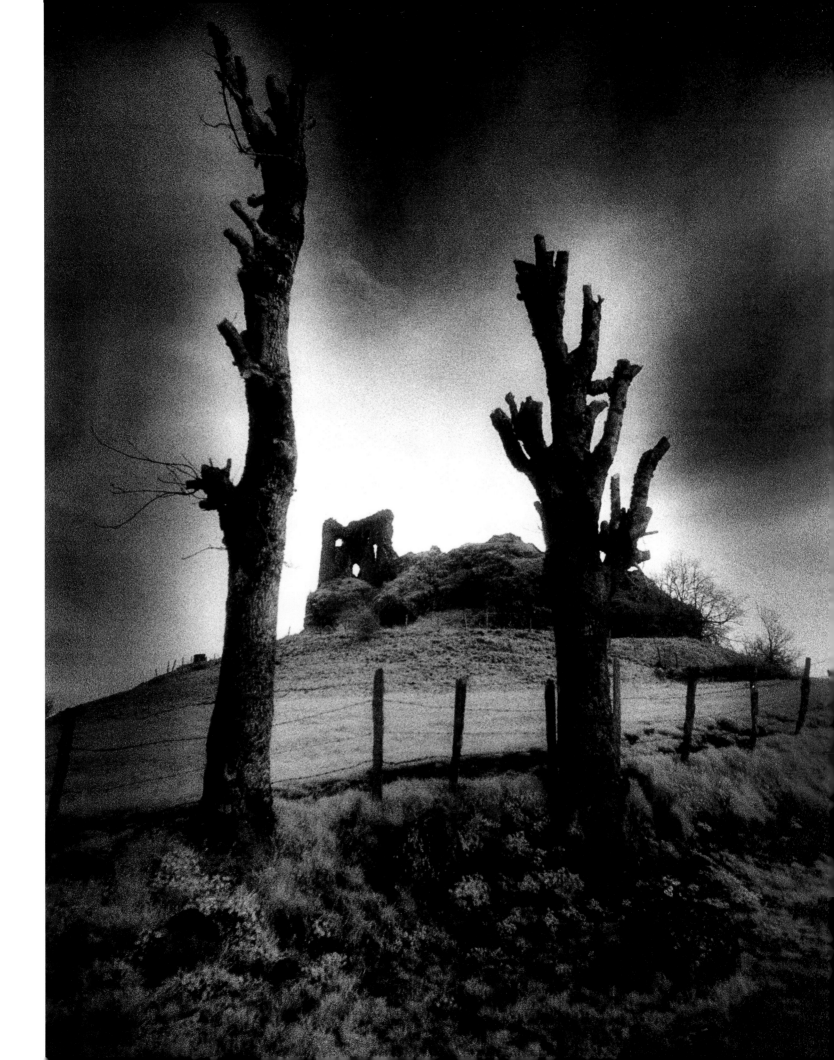

The House of the Templars
- 24–25 October -

The drive through the Cantal Mountains had been unforgettable, especially the dramatic views into the mysterious volcanic landscapes in the valleys below. I was now within sight of the old medieval town of Salers, superbly situated on a basalt plateau at an altitude of nine hundred metres. Little altered since the fifteenth century, it is an extraordinary example of the architecture of those times. Once a medieval fortress and law court, which sheltered merchants, jurists and nobles from English and Huguenots attacks, there is still evidence of its prosperous past.

It was evening, and I needed somewhere to sleep for the night, so I headed for the fourteenth-century Maison de la Ronade. The owner, Jean-Pierre Lagane, is a journalist and author with great knowledge of the Templars.

He recommended a restaurant and, after a wonderful meal of local delicacies—the region is known for its beef and cheeses—I found a bar for a nightcap and began talking with the locals. One man was particularly knowledgeable on the folklore and customs of the Auvergne, and told me that the 'old religion', paganism, was still practised here. The cult of the 'Black Virgin' (see Chartres Cathedral, pages 36–37), the fervent devotion to ancient statues thought to represent the divine feminine, still has many followers in the region, who worship in little-known shrines and caves. Strong religious folk traditions connect the Black Madonnas to the medieval Knights Templars.

The next morning I awoke with a hangover, but Monsieur Lagane and his wife were sympathetic—as well as amused. We spoke

at length about the Templars and their associations with Salers. As I left my host shook my hand and wished me luck, unnervingly adding, 'I have learnt that it is sometimes wiser not to delve too deeply into the Templars' secrets. They are still a powerful force.'

Walking through the town again, I marvelled at the many ancient doorways and the strange carvings over the lintels. My destination was the House of the Templars used by the Knights Templars as a stopover on their journey to Compostela. Now a museum, I entered through a twelfth-century door into a beautiful vaulted passageway. The symbolism of the Gothic arch offers proof that this must have been a centre for Templar activities. Once the heavy, studded wooden door is closed, a strange androgynous figure is revealed: the eyes seem oriental, the chin is bearded and the hair is long and feminine, adorned by a crown of leaves. On the ceiling of the chamber are four medallions. The most interesting, like the figure hidden by the door, has almond-shaped eyes, a beard, and hair like an Egyptian pharaoh's.

As I began photographing, I remembered what I had once read about the secret ceremonies and initiation rites of the Knights Templars: they were said to drink a toast from a hollowed-out human skull to a devil known as *Baphomet*—traditional Satanists believe the name means 'Mistress of Blood' or the 'Dark Goddess'. They would then prostrate themselves in front of a bearded male head, which spoke to them and invested them with occult powers.

above and facing page
Medallion, house of the Templars at Salers

DORDOGNE — PALUEL CHÂTEAU

A Gothic Dream

- 26 October -

A friend who has a great interest in ruins told me about Paluel Château. Burnt down by German troops in 1944, he said that many people considered it to be the most beautiful ruin in the Périgord. He has written extensively on the château and remains fascinated by its history, by the curious underground passages that he believes date from medieval times, and by the more recent discovery of a corpse in an old well.

Leaving the ancient town of Sarlat, I drove for about eight miles before I could see, high on a hill, the romantic outline of the ruined towers, partially hidden by ancient trees. Originally built between the thirteenth and fifteenth centuries, it was partially remodelled in the fashionable neo-Gothic style during the nineteenth century by the Prince de Croÿ, who lived there between 1889 and 1931. The present owner, Professor Jean Lassner, built a beautiful house below the castle but he never had the funds to restore the château, which he warned me is now in a very dangerous state. During the Second World War the Resistance was very active in this area, and the ancient tunnels beneath the castle had been used to store arms. When the Germans discovered this they set light to the château, which is said to have burnt for over a week.

Professor Lassner also confirmed the story of the body in the well. The victim was a young man, a local drug dealer, and his murderers hid his body on this remote site. He said he didn't know if the building was haunted, but thought it possible that the Resistance might have invented stories to keep people away. He warned me to be careful when taking pictures inside—the floors are unsafe and the entrances to the tunnels sometimes hidden.

Walking up the hill I felt uneasy—why, I have no idea. Climbing over some stones from a collapsed wall, I found myself in an overgrown garden with an ornate, weathered fountain. Everywhere I looked were images of desolation: the melancholic beauty of faded grandeur. The entrance to the castle's courtyard is through a medieval arch. Now I felt I was in a lost world, and a feeling of great sadness enveloped me. Approaching the main door, I marvelled at the beauty of the coat of arms above it. The carvings in the interior are often remarkably well preserved, but many of the broken stone staircases now lead nowhere and ivy creeps over the walls like a shroud.

I was entranced by a large room that seemed to be a chapel. Lit only by the sunlight from the arched windows, the Gothic bays and carved doorways seemed to glow with a strange light. As I set up my tripod, the feeling of sadness swept over me again. Whether it came from within me, a consequence of my own particular darkness, or was the remnant of something terrible that had taken place within these ancient walls, I cannot tell. I have an affinity with these buildings. Are they perhaps part of a universal subconscious, representing a mystical and spiritual solitude?

above
Interior, Paluel Château

facing page
Paluel Château

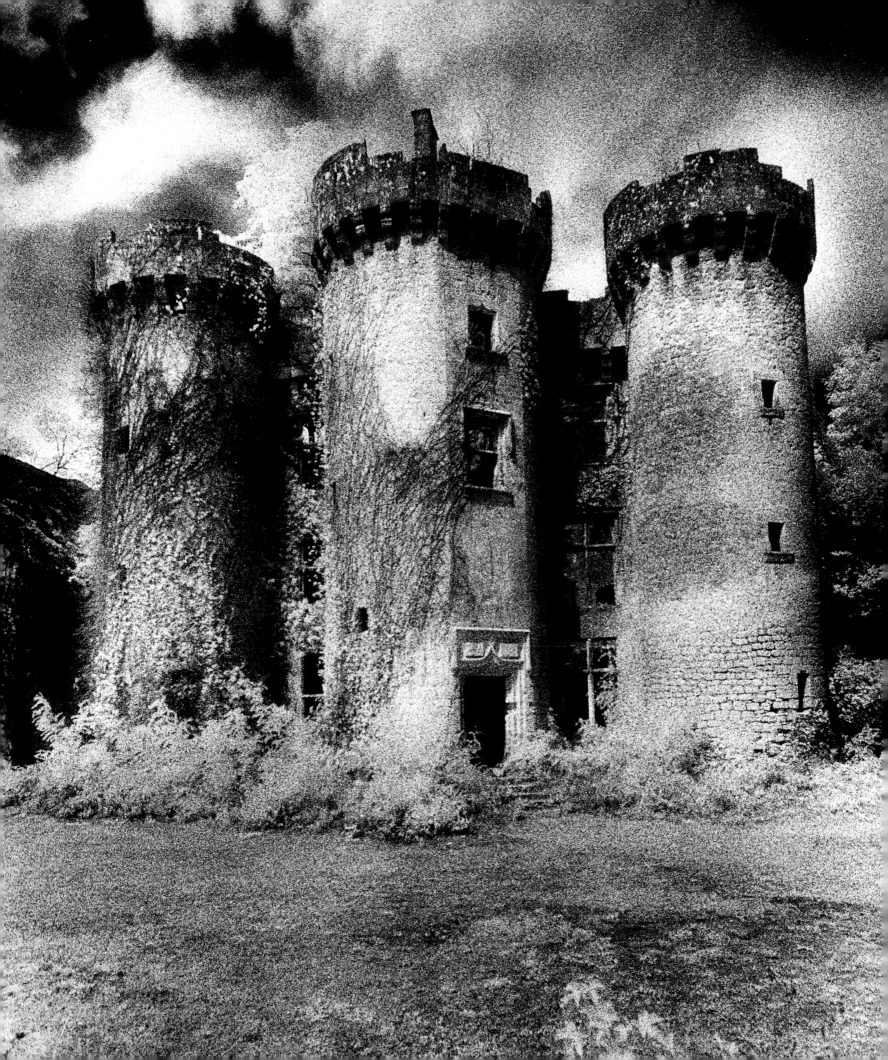

DORDOGNE – L'HERM CHÂTEAU

The Legend of the Wax Hand

- 27 October -

The first written mention of the château dates from the fourteenth century, when it belonged to the L'Herm family. By the fifteenth century it had passed into the hands of Jean II de Calvimont, the lord of Tursac, who embellished the castle in the flamboyant Gothic style. As I climbed the great stone staircases to view the floorless rooms, I felt the presence of more than just memories.

The eerie ruin is the setting for a traditional ghost story known as the 'Legend of the Wax Hand'. In the fourteenth century, the Baron de l'Herm had a beautiful daughter called Jeanne. She was just sixteen when one of the pages, Gontran de Bourdeille, entered her bedroom one night and declared his undying love for the princess. Jeanne was equally smitten but, in his rush to take her in his arms, Gontran accidentally knocked over the baron's battleaxe, which hung on the wall. As it fell the sharp blade severed Jeanne's hand. Doctors could not save her hand, so they modelled her a wax one, so perfect that nobody could tell the difference. The baron was naturally unsure about his daughter's lover, but did not stand in the way of their marriage. On their wedding night Gontran vowed to Jeanne that she only had to raise her wax hand and he would obey her every wish.

As time passed, Gontran's behaviour deteriorated: he began drinking too much and treating his wife badly. One night he returned to the château, very drunk, with some of his idle friends. In the confusion that followed, the baron had a heart attack and Jeanne fainted. She came to in her bedroom in the arms of Aymar de Milhac, a handsome troubadour, who comforted her with soothing words. She had almost forgotten the horror of her husband's actions when suddenly he smashed down the door and seized the same battleaxe off the wall, threatening to kill them both. Jeanne stood up and raised her wax hand reminding him of his promise and begging him to let the troubadour go alive.

Aymar started to leave but, just as he reached the door, her terrible scream shattered the night. From this time onwards it is said that a woman in white haunts the castle's chambers, in an eternal search for her lost love.

The building is also cursed by real-life tragedies, a legacy of murders and assassinations that have left an indelible mark on its history. The litany of violence was at its height in the sixteenth and seventeenth centuries, when the Farges and Calvimont families vied for control of the château and its lands. Anne d'Abzac de la Douze, a member of the Farges family, collaborated with her son-in-law, François d'Aubusson, in the murder of her own daughter, Marguerite de Calvimont. Soldiers in the pay of her husband strangled Marguerite to death in her bedroom. François believed that he would inherit the Calvimont fortune, and would then be free to marry his lover, Marie de Hautefort. But Marguerite's father had made a copy of her will, which decreed that—if she died childless—her inheritance would go to her cousins. Her mother Anne quickly accused François of Marguerite's murder, but said she would withdraw her accusation in exchange for property and lands. He agreed, but his desire to keep Anne silent proved his own guilt. He died in prison in 1618.

The land of L'Herm belonged to the Hautefort family up until the Revolution, but by December 1714 an inventory of the estate described the castle as abandoned, its roof collapsed and the lands unkempt. The empty shell of this tragic château is inhabited only by the pitiful ghosts of those who suffered here.

facing page

L'Herm Château

pages 140–141

Interior, L'Herm Château

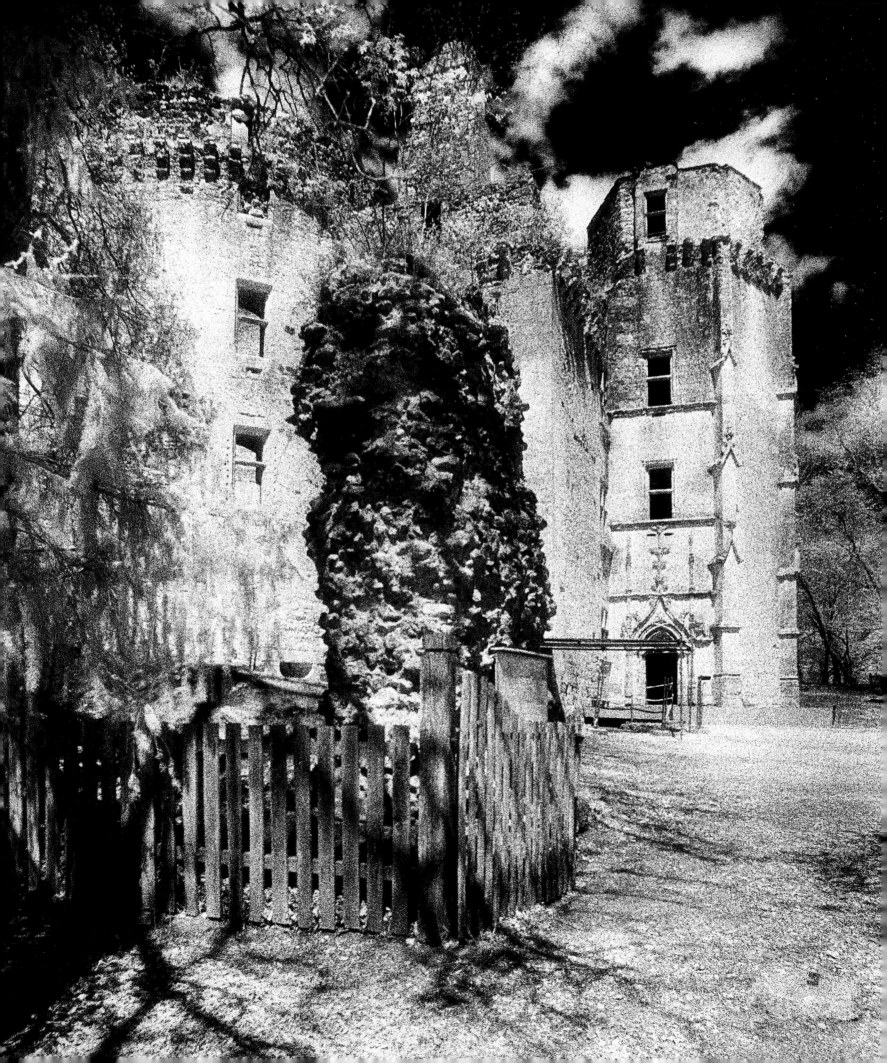

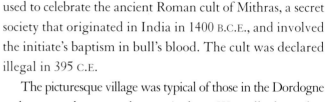

DORDOGNE - MONOLITHIC CHURCH OF SAINT-JEAN, AUBETERRE-SUR-DRONNE
Supernatural Forces
- 28–29 October -

About twenty-five years ago, a good friend, a photographer whose work I greatly admire, went to live in the Dordogne with his family. We shared the same interest in old buildings and anything—shall I say—spiritual. Now I had the chance to catch up with him and we spent a wonderful evening discussing our lives and work. Just before going to bed, he smiled at me and said, 'Tomorrow I am going to show you somewhere more unusual, more powerful than anywhere you have ever been before.'

The next morning, as we drove towards our destination, he began to fill me in on what to expect. In a small hilltop village, dominated by a limestone cliff, is a vast, cathedral-like structure hewn into the rock, with massive pillars creating a chamber the height of Notre-Dame. The original grottos are very ancient, and were inhabited by early Christians trying to escape persecution. Then, in the twelfth century, Benedictine monks enlarged the caves. The nave of the church acted as a cemetery until 1865, where layer upon layer of the dead were laid to rest over the centuries.

A burial chamber to the west side of the nave is left uncovered to reveal eighty sarcophagi that were carved into the rock. A magnificent two-tiered hexagonal monument, six metres high and three metres in diameter, carved from solid rock is either a reliquary of bones or a mausoleum thought to belong to the lords of Aubeterre. In 1848 it was found to hold four coffins; two of these contained the remains of children. Another subterranean room was accidentally discovered in 1961, when a passing lorry collapsed the road. This chamber is thought to have been used to celebrate the ancient Roman cult of Mithras, a secret society that originated in India in 1400 B.C.E., and involved the initiate's baptism in bull's blood. The cult was declared illegal in 395 C.E.

The picturesque village was typical of those in the Dordogne and gave no clue as to what awaited me. We walked together down the hill and, after a few hundred metres, saw the small opening to the church. It was like walking into the side of a mountain, and all my friend's preparatory descriptions of the site were made inadequate by the awe-inspiring vision before me. I truly felt as if I had entered another world. Dark and cold, my first instinct was to look upwards to the summit of the great columns and the windowed galleries above. I was told that visitors have reported hearing strange whispers and seeing dark shadows flitting between these vast pillars and along the narrow galleries.

Later, as I photographed the skulls and bones lying on top of some of the tombs, a sudden feeling of dread enveloped me. Retreating outside, I eventually regained composure, and we went for a drink in the village, where we began chatting with some of the locals. Since childhood they had heard rumours of secret ceremonies and strange chanting in the vicinity of the château and apparently there is a passage from the castle to the church, but this has now been filled in. To them the church has always been a mysterious place, and words can not adequately describe the forces that seem to permeate every corner of this extraordinary monument.

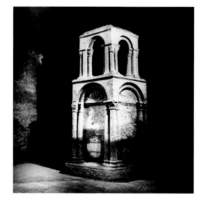

above
Mausoleum, Monolithic Church of Saint-Jean

facing page
Human remains, Monolithic Church of Saint-Jean

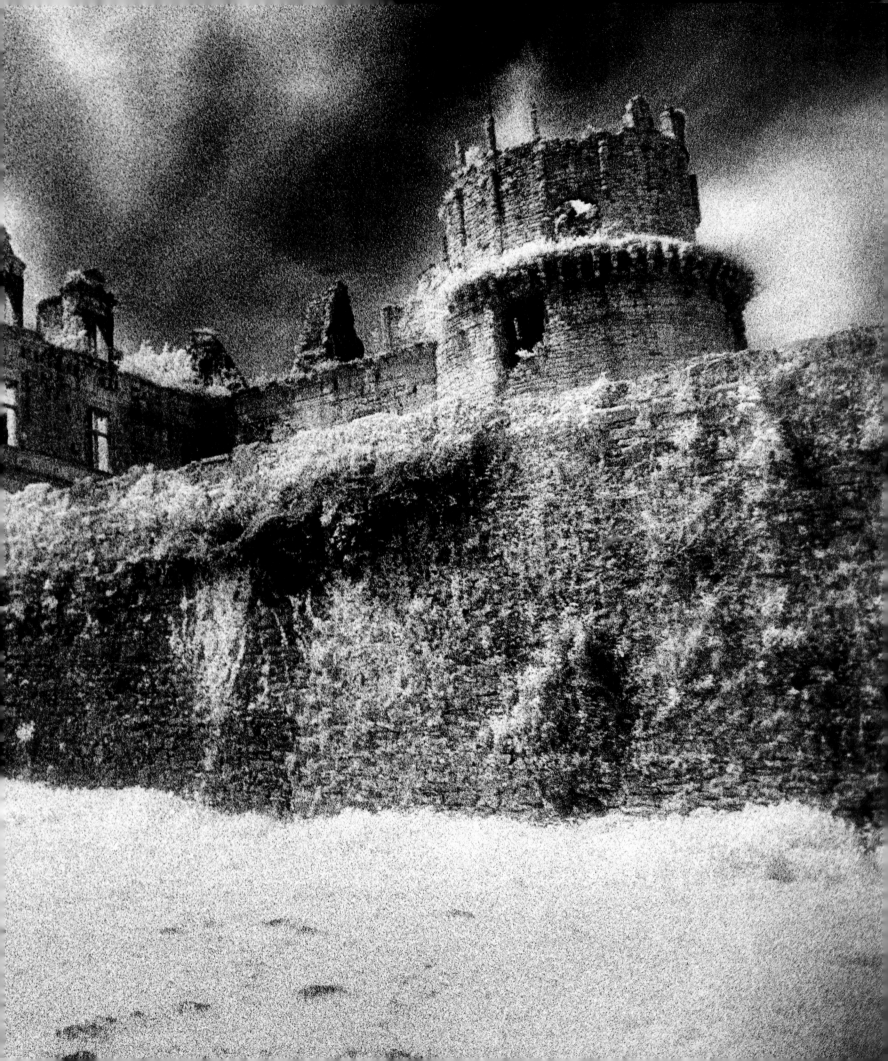

Eternal Damnation

- 2 November -

Only the Moncade Tower and a few crumbling ramparts still remain of the once powerful Orthez Château. This was the seat of Gaston Phebus (1331–1391), count of Foix. Phebus was a musician, poet and the author of one of the most beautiful books of the Middle Ages, the wonderful *Livre de la Chasse* (The Hunting Book). He was also a great warrior, who made Foix one of the most influential and powerful domains in France. But this handsome man with long blonde hair was also said to have had a ruthless, dark side, and this fortress was the scene of his greatest crime.

In 1380 Gaston's only legitimate son was traumatized when his mother, Agnes de Navarre, was banished from the castle by his father. Agnes's brother, Charles le Mauvais, the king of Navarre, was equally outraged: he began plotting his revenge using Gaston's son, also named Gaston, as a pawn. He presented the boy with a pouch filled with a mysterious powder, telling him that it was a powerful love potion and that he must put it in his father's food. This way, Charles promised, his father would fall in love with young Gaston's mother again and beg for her return.

The gullible prince agreed, but somehow the purse fell into the hands of his jealous illegitimate brother, Yvain, who gave it to his father. Suspecting some form of treachery, the count covered a piece of bread with the powder, and fed it to a dog—with fatal results. Over the following month, the prince's servants and friends were mercilessly tortured to disclose the name of the plotter. Gaston's son had so far been spared such horrors, but—locked in a cell—was starving himself to death rather than betray Charles. Late one night, in exasperation, Gaston went to his son's cell in a final attempt to reason with him. Still the young man refused to talk; his father, in a fit of rage, stabbed him through the neck, killing him. It is said that his pathetic ghost still haunts the tower and the screams of his friends can be heard, echoing from the dark dungeons.

According to French historian Jean Froissart, (c. 1337– c. 1404/5), from that day on Gaston was a changed man. Finding it hard to sleep, he always left a lit candle by his bed—some said, to keep the phantoms at bay. He was to die a broken man in 1391.

Meanwhile, having inherited his father's estate, Yvain became a favourite at the royal Court. He had a gift for organizing magnificent parties, and it was his idea that King Charles VI, 'the Mad', (1368–1422) should host a ball at which Yvain and the king should appear with four wild men, all locked in chains. Their linen costumes were covered in oakum mesh and coated with pitch, so the heralds gave orders that all torches were to be kept at a distance. But one eager courtier, wanting to see the performers' faces more clearly, came too close, and the line of chained men became a human inferno. Only the king's life was spared.

Another ghost said to haunt this cursed tower is that of Blanche de Navarre. In 1453 she became the heiress to the powerful kingdom of Navarre, but in 1461 she was imprisoned at Orthez by rivals, including her own relatives. The cruellest of these was her jealous sister, Eleonore. Here Blanche was assaulted and tortured until her captors finally poisoned her in 1464.

The tower is a very dark place where the light of salvation has long since been extinguished.

facing page
Orthez Château

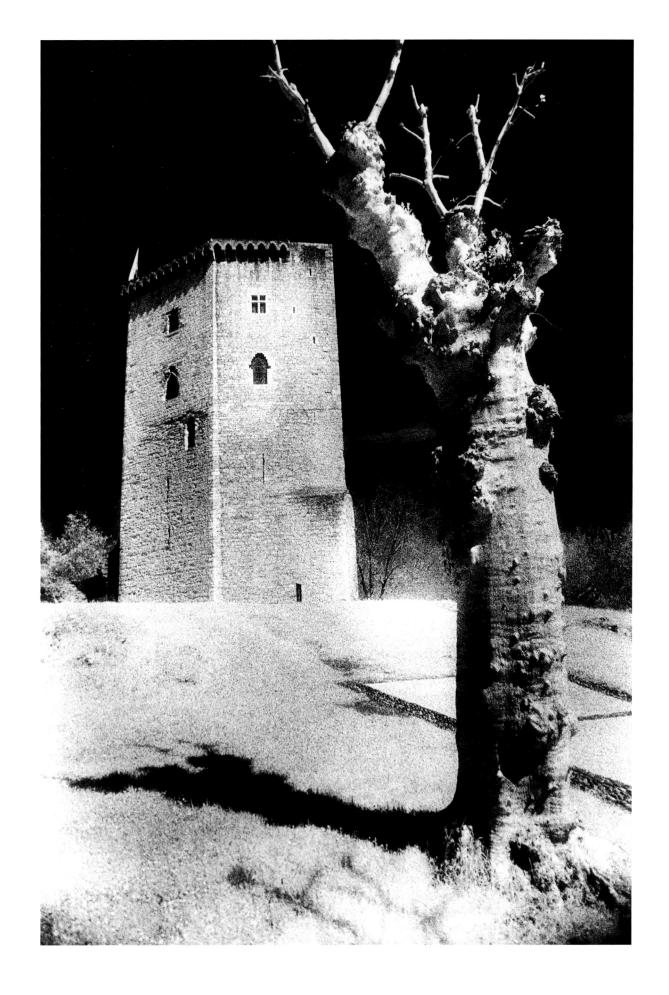

Secrets of the Templars
- 3 November -

Of all the sites in the Pyrenees that rekindle memories of the Knights Templars—the warrior monks with strange powers—this is surely the most evocative. Although no trace of the Templars' château at Montsaunès remains, this church contains extraordinary murals and symbols, many now sadly defaced by human hand or time. The predominant colours of pink, white and rose-red are hypnotic, casting a spell on the onlooker. I longed to know their true meaning.

The west door of the church is the most richly decorated. Beneath the arch are twenty-six pairs of sculpted human heads, very close together and often turned towards each other. In the centre the faces appear serene, but the lower down one looks, the more unfriendly the faces become. At the bottom they are grotesque, strongly resembling the masks from ancient theatre. The higher faces appear very dignified, without a trace of vulgarity; several have dark skin and are of Middle Eastern appearance. It is interesting to note that one of the charges laid against the Templars by Philip IV of France (1268–1314), when he decided to persecute them in the fourteenth century, concerned their links with the Muslim world. It is claimed that, during the crusades, secret connections were made with their Muslim equivalents, the Hashishim or Assassins, a sect of fanatical militant adepts, and that the Templars had learnt many occult practices from these infidels. The lower faces are very different: they all have beards and frizzy hair, and some have their mouths open, revealing menacing square teeth. Their grimaces and their terrifying aspect are accentuated by the look in their eyes. When the Templars ordered this frieze, it certainly would not have been without reason. The easiest explanation would be to say that those at the top are closer to God and those lower down are hideous because they have been tortured by their vices. But there are many historians who feel that there is more to this ancient sculpture than meets the eye.

I needed a ladder in order to photograph the heads, but there was no one around to ask for one. Then, across the road, I saw a young man sweeping the yard of a large house. I entered the gates and within minutes he was carrying a large stepladder to the church door for me. After I had taken the pictures, he took me inside the church and showed me some very detailed modern illustrations of the murals, which had been drawn by an Italian. They showed the paintings as they would have been originally and were mesmerizing. He said that his father had spent a lifetime studying the Templars, and that it was a subject that always seemed to throw up more questions than answers. Later, as we were leaving the church, he asked with a smile whether I hoped to discover something here. When I asked exactly what he meant, he shrugged his shoulders and replied, 'The whereabouts of the treasure, of course.'

As I was getting into my car, I turned to see him staring up at the heads I had just photographed. How did he interpret them, I wondered? All I could be sure of was that this exceptional church was one more clue to the unspoken mystery surrounding the Order's secrets.

facing page and pages 156–157
Heads over the west door, Templars' church at Montsaunès

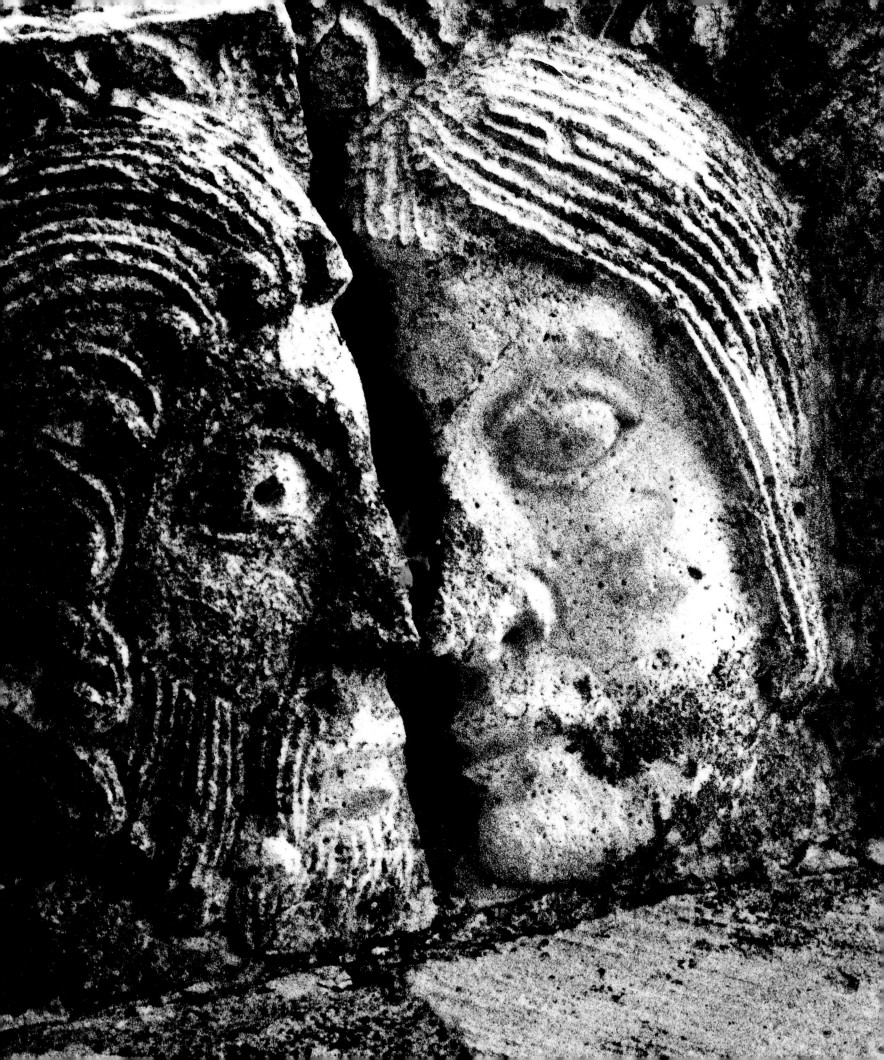

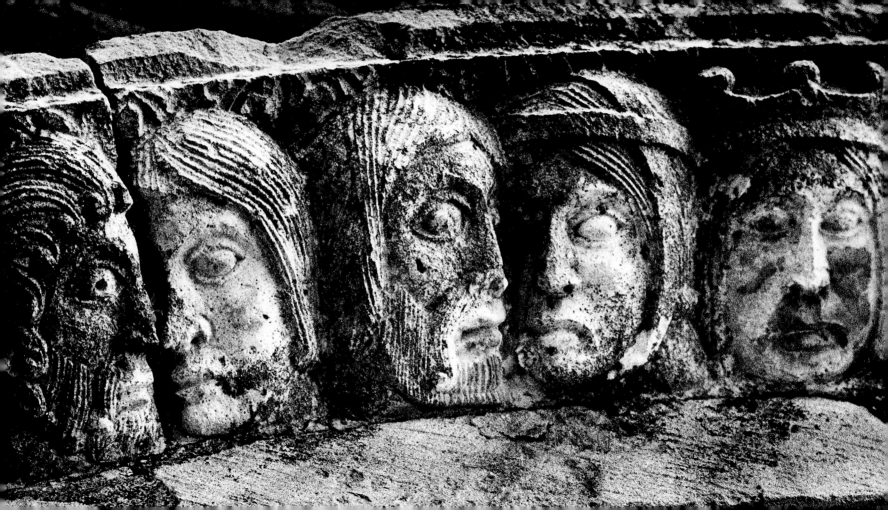

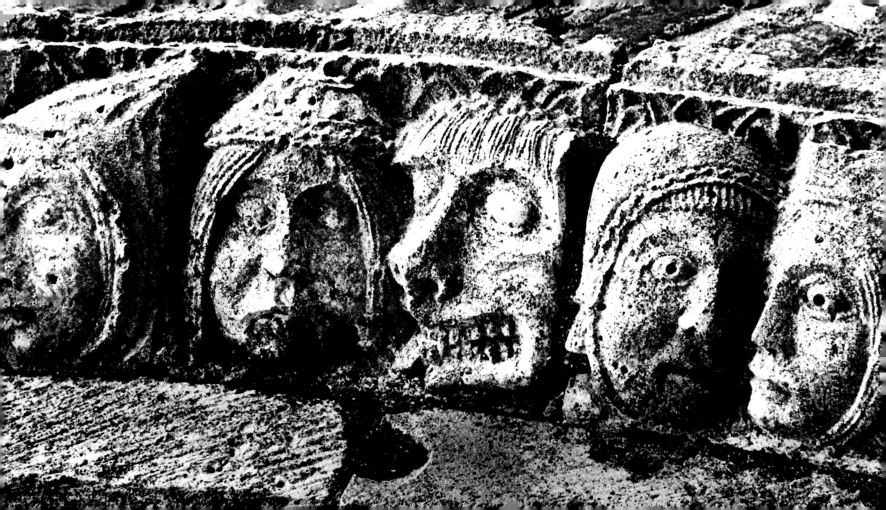

The Mystery of Rennes-le-Château

- 4 November -

The tiny hilltop village of Rennes-le-Château has been occupied since prehistoric times and was regarded by the Celtic tribes as a sacred site. During the fifth century it was a prosperous town called Rhedae, an important citadel of the Visigoths, who had toppled the Romans and established a kingdom in the Pyrenees. The stronghold was later besieged and captured from Cathar supporters during the Albigensian Crusade in the thirteenth century. In 1362, the population was wiped out by the plague and the town destroyed by Catalan bandits. It never recovered, and became the small but mystical village it is today.

In 1885, a new priest, Bérenger Saunière, was appointed. Thirty-three years old, handsome, well educated, but of modest means, he was something of a rebel and was thought to have been sent to this remote village by his superiors as a kind of punishment. For six years he led a quiet life until, in 1891, he began restoration work on the village church of Saint Mary Magdalen. When the top of the high altar was lifted, one of the two sculpted Visigoth columns supporting it was found to be hollow. Hidden inside were several wooden tubes containing rolls of parchment. Two were genealogies dating from the thirteenth and seventeenth centuries; the others were coded documents composed in the eighteenth century by Abbot Antoine Bigou. Bigou had been personal chaplain to the Blanchefort family, who had lived at the Seigneurs Château in Rennes, and who were said to be the guardians of 'a very great secret' passed down from one generation to the next.

Realizing that he had discovered something of importance, but unable to decode it, Saunière took the manuscripts to his superior, the bishop of Carcassonne, who immediately sent him to Paris to consult with religious experts there. Saunière stayed in Paris for three weeks, mysteriously returning a very rich man, and over the following years continued to carry out secret excavations beneath the church and in the graveyard. He built the villagers a mountain road, installed a water tower, and enjoyed a lavish lifestyle in the company of his housekeeper and confidante, Alexandrine Denarnaud. He also built a Renaissance-style house, the Villa Bethania, and a neo-Gothic tower known as the Magdala Tower. His most remarkable contribution, however, was the elaborate decoration of the church. It was filled with brightly coloured, almost surreal tableaux depicting the Stations of the Cross, strange statues, and a bas-relief below the altar that was almost the exact replica of a stained-glass window in a nearby church. However, all of the figures and paintings contained some bizarre deviation from the traditional version. Another hidden code yet to be deciphered? Above the entrance to the church was a Latin inscription that read, *Terribilis est locus iste* (Dreadful is this place), and just inside the door was a horrific statue of a demon holding up the font, which has been identified as Asmodeus, the guardian of King Solomon's legendary treasure.

above, left
Alexandrine Denarnaud 1868–1953

above, right
Abbot Bérenger-Saunière 1852–1917 (right)

facing page
The demon Asmodeus, Church of Saint Mary Magdalen

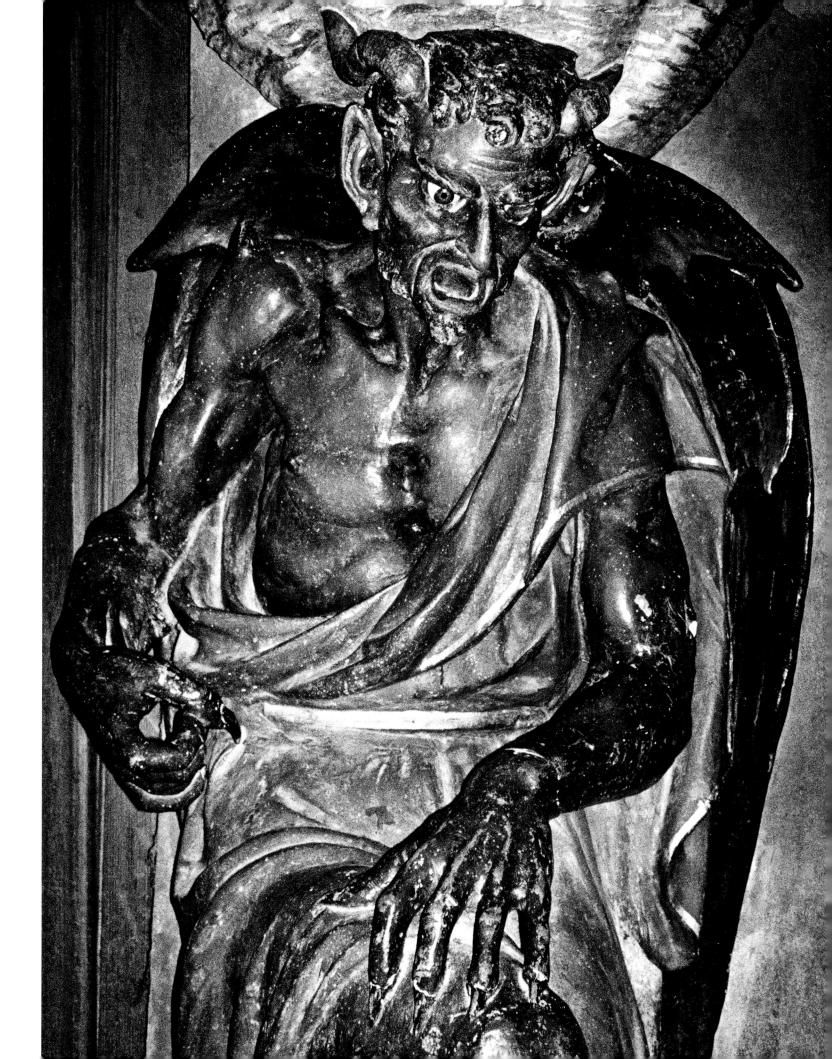

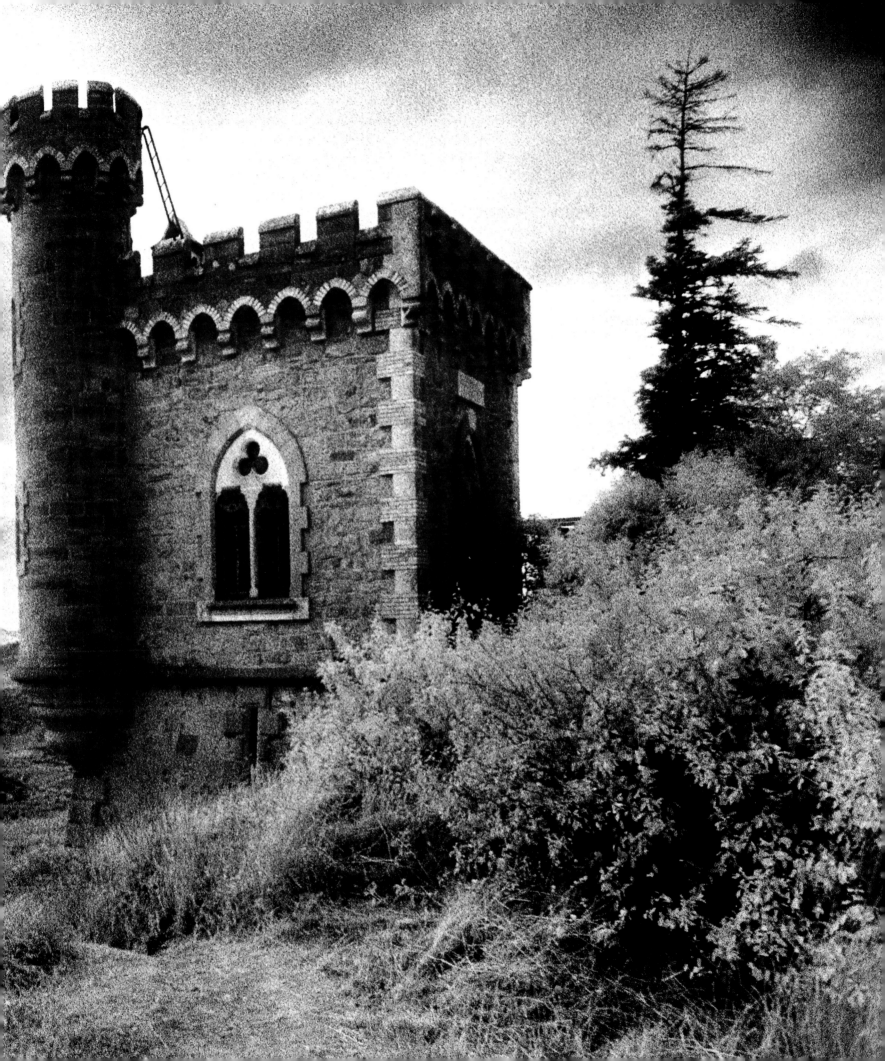

What had Saunière found, and how had he suddenly become so rich? There are only two clues. On his return from Paris after discovering the parchments, he brought with him the reproductions of three paintings. One of these, Poussin's *Les Bergers d'Arcadie,* together with a tomb in a nearby village, is thought to hold the key to deciphering the codes in the parchments. Another possibility was that he had discovered the secret that had been passed down to Abbot Bigou by Lady d'Hautpoul de Blanchefort, the last in the Blanchefort family line. But what exactly was that? Could it have been regarding the legendary Cathar hoard that was smuggled out of Montségur Château before it fell to the Crusaders? Bertrand de Blanchefort had been a Grand Master of the Templars: was it the vanished treasure of the Knights Templars? Or was it the gold that the Visigoths were reputed to have hidden here? There is, of course, another possibility: it was not treasure, but an ancient secret so important that an organization or individual was prepared to pay a great deal of money for Saunière not to divulge it.

Because of Saunière's controversial lifestyle and behaviour, the bishop of Carcassonne eventually suspended him from his duties, but he appealed to the Vatican and was immediately reinstated. Then, on 17 January 1917, at the age of sixty-five, he suffered a stroke, dying five days later. He is said to have made a confession on his deathbed that so shocked the priest who heard it that he refused to administer the last rites to Saunière.

Some time before his death, Saunière had transferred his wealth to Alexandrine Denarnaud and she continued to live a comfortable existence at the Villa Bethania. In 1946 she made the Corbu family legitimate heirs to her estate, promising before her death to tell them a secret that would make them rich and powerful. But, like Saunière, she died of a sudden stroke, and it is believed she took the secret with her to the grave.

In the small museum bookshop, I spoke at length with one of the curators. She told me how Saunière, who owned a large collection of esoteric books, used the Magdala Tower as a library. She also told me that one of the rooms in the Villa Bethania is believed to be haunted, and that some guests had once had to leave suddenly in the middle of the night because of something they had seen. An ancient skeleton was discovered in front of the main door to the villa when workmen were digging up the road in the early part of the twentieth century. She also added that several ancient legends are linked to the Seigneurs Château in Rennes, home to the Blanchefort family, which contains many secret dungeons and passageways. One tells that, in the caves linked by these underground tunnels, lives a race of troglodytes, unaware of the passing of time and the light of the day.

I suddenly felt eager to escape from this overwhelming place. Now deep within the dramatic mountain landscape of the Pyrenees, I was keen to visit some of the principal châteaux of the 'Pays de Cathars', to try and discover more about this strange sect's beliefs, the legend of their treasure—and their possible connection with the Knights Templars.

page 160–161
The Magdala Tower

facing page
Bas-relief beneath the altar, Church of Saint Mary Magdalen

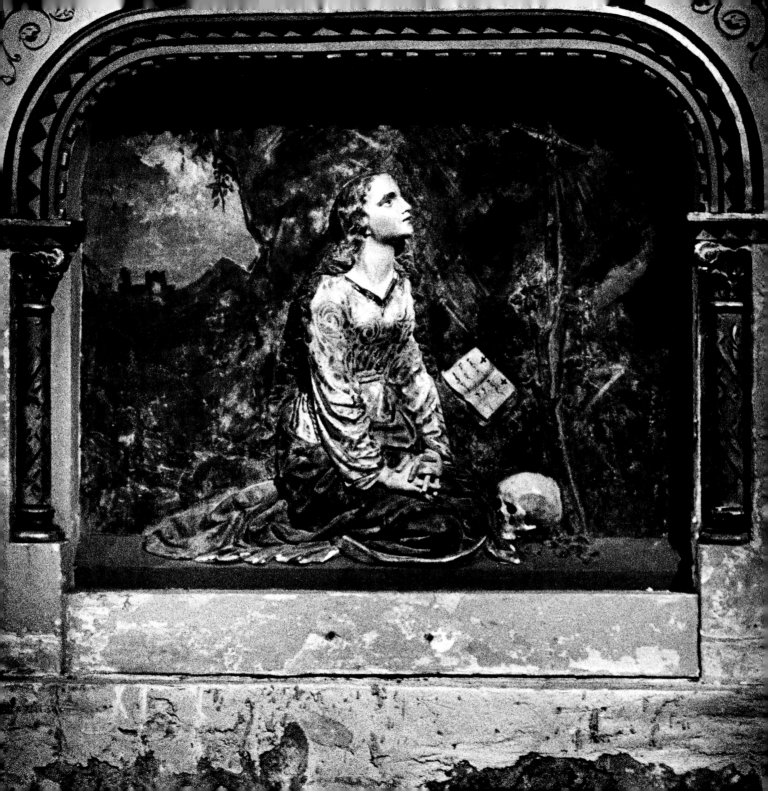

PYRENEES — PEYREPERTUSE, QUÉRIBUS, MIREPOIX, PUIVERT AND MONTSÉGUR
Ghosts of the Cathars
- 5–8 November -

At the beginning of the thirteenth century, the area known as Languedoc was not officially a part of France, and its culture was very different from that of any of its European neighbours. *Langue d'oc* is French for 'language of Oc', and it was so-called because *oc*—rather than the Old French *oïl*—was the word used for 'yes' in this region. This small but unique civilization had created a society that rejected the prevalent ethics of the age—pursuing personal ambitions through suppression and violence—for the more civilized morals of gaining personal dignity through the love, trust and tolerance of all things. The inhabitants succeeded in creating beauty in all forms of architecture, literature and the arts, and nowhere was this better portrayed than in the cult of the troubadours—travelling poets and musicians who, through their love songs, preached a message of understanding rather than force, persuasion rather than conquest.

As this new age of tolerance began gradually to spread through the rest of southern France, Spain and northern Italy, people became impatient with organized religion, especially the Catholic Church, which seemed to be in disarray. All too often it appeared to be indulging in unseemly acts of pomp and splendour, and many of its priests were seen to be leading hypocritical and profligate lives. Out of this disillusionment grew a powerful sect known as the Albigensians, named after the city of Albi in Languedoc which was one of their centres. They were also known as Cathars, which comes from the Greek word meaning the 'pure ones'. The roots of this faith lay in Manichean dualism of the third century, which had occult and magical overtones. It taught that God and the Devil were equally powerful, and that the material world was a kingdom of darkness created and ruled over by the devil. Into this evil world had come the pure word of Christ, who was God's ghostly presence, a Holy Spirit to be worshipped. According to the Cathars, redemption came not through Christ's death on the cross, but from the example of life he led on earth. Not believing in intricate and costly ceremonies, the Cathars wore simple robes and were said to have been extraordinarily gentle in their behaviour, their faces reflecting the purity of their soul. Poor people, especially, were able to identify with such a simple faith.

above
Figure of a troubadour, Puivert Château

facing page
Puivert Château

As the Cathars' influence grew, the Church naturally became alarmed, especially when almost the entire aristocracy of southern France became followers of what the Catholic bishops were beginning to describe as a heresy. In 1209, the ironically named Pope Innocent III (1160–1216), with the support of the French king, called for a crusade against the Cathars, declaring that 'anyone who attempted to construe a personal view of God which conflicted with Church dogma must be burned without pity.' A vast army of knights and mercenaries, many of them English, descended from the north of the country to take part in a horrific slaughter and inquisition that was to last for almost half a century.

The pope had decreed that all those taking part in the crusade were to be absolved in advance of any sins they might commit, and that anything of value belonging to the Cathars or their allies would be considered as booty. The Albigensian crusade began with the siege of Béziers, where the crusaders demanded that the city fathers hand over the small number of Cathars known to be hiding there. They were refused, and the order was given to massacre every man, woman and child of the twenty thousand inhabitants. When the pope's representative was asked how they would be able to distinguish the heretics from the faithful, he answered: 'Kill them all: God will recognize his own.'

The following thirty-five years witnessed some of the most violent massacres since the fall of the Roman Empire.

Thousands of Cathars were tortured, left to die in chains or burnt alive for their beliefs. By 1243, almost all recognized resistance had ceased, except at a small number of isolated strongholds, one of which was Montségur Château. On 16 March 1244, after a ten-month siege, some two hundred Cathars were burnt alive here, and the fortress and the faith of these martyrs became a legend.

Today, the mystery and spirit of the sect is still alive, and the ruins of their castles have become sites of pilgrimage for many people from all over the world. Two of the most impressive and inaccessible of the Cathar castles are Peyrepertuse and Quéribus, high in the Pyrenees. Given their remote position, it is hard to understand how they were ever captured. Peyrepertuse is a fortress within a fortress, high up in the clouds. Its many crumbling walls are said to be haunted by a ghostly procession of Cathar *perfecti*, the name given to the most holy members of the sect, who are said to have starved themselves to death rather than submit to the torturers of the Inquisition. I doubted whether many visitors would dare to remain within the castle's walls after dark to witness these robed phantoms.

Quéribus is the most dramatic and remote of all the castles. Carved, literally, out of the rock, it appears like some giant's finger pointing towards the heavens. Having climbed up the many steps to the fortress in the afternoon sun, I was relieved to reach the cool inside of the well-preserved keep

facing page
Peyrepertuse Château

with its impressive Gothic interior. Here, in the semi-darkness, I tried to imagine how these holy men and their loyal soldiers must have felt, cut off from the rest of the world and awaiting almost certain death at the hands of the besiegers. The haunted expression on the faces of two German tourists, who shared the room with me, suggested that they must have been thinking along similar lines. A cold shiver ran down my spine. I began the long climb back down, but this time I felt that something or somebody was following me. Perhaps it was just a feeling…. That night I woke screaming from a horrific nightmare. I was imprisoned in a dark cell that was floating somewhere in space. It was filled with skeletons and dimly lit by one white candle that had only an inch of wax left to burn.

The following day I passed through the ancient town of Mirepoix, which had given shelter to many of the Cathar 'heretics' in their unequal struggle against the crusaders. After lunching in the main square, I photographed the mysterious medieval sculptures that adorn the House of the Consuls, which so vividly reflect the violence of those times. As I stared through the camera lens, I sensed that these grotesque, eerie faces, sometimes almost concealed by dusty cobwebs, seemed to hold an ancient secret, like those at the Templar church of Montsaunès (see pages 154–157) It was as if they were mocking passersby, challenging them to discover this arcane knowledge.

Many aristocratic families in the area were followers of either the Knights Templars or the Cathar sect—sometimes both. One such was Bernard de Congost, the lord of Puivert Château. In 1210 the crusader army of Simon de Montfort laid siege to the castle. After three days of fierce fighting, de Congost, realizing that all was lost, fled with his soldiers through a secret passageway below the fortress. The entrance to this passage has never been found. In the middle of the castle stands an impressive keep, or donjon, and at the summit is a remarkable chamber known as the Musicians' Room. This contains the striking statues of eight musicians, each playing a different instrument. I was reminded of the tradition of the troubadours in this region, and how they included coded messages in their music and songs as they travelled between these remote castles. This was one of the only forms of communication in such dangerous times. Ghostly music has been heard in this tower on certain nights, and the spectre of a White Lady has been seen in the castle. She is believed to be a princess of Aragon, who drowned in the nearby lake.

De Congost finally met his end at Montségur Château, the spiritual heart and final refuge of the Cathar faith. It had been built on what has always been known as a holy mountain, some four thousand feet above sea level, and in May 1243 it was recorded that there were around two hundred Cathars and three hundred soldiers within the walls, surrounded by a besieging army of ten thousand men.

facing page
Steps up to Quéribus Château

page 170
Double-headed carving, House of the Consuls, Mirepoix

page 171
Carved wooden heads, House of the Consuls, Mirepoix

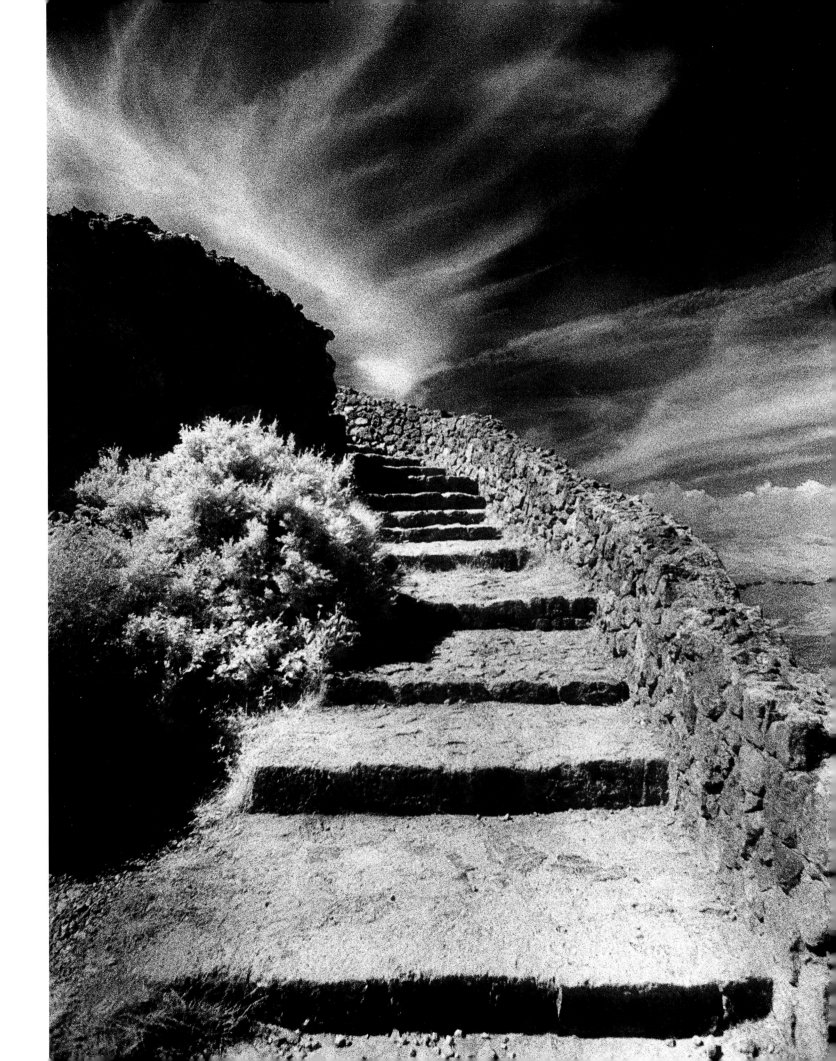

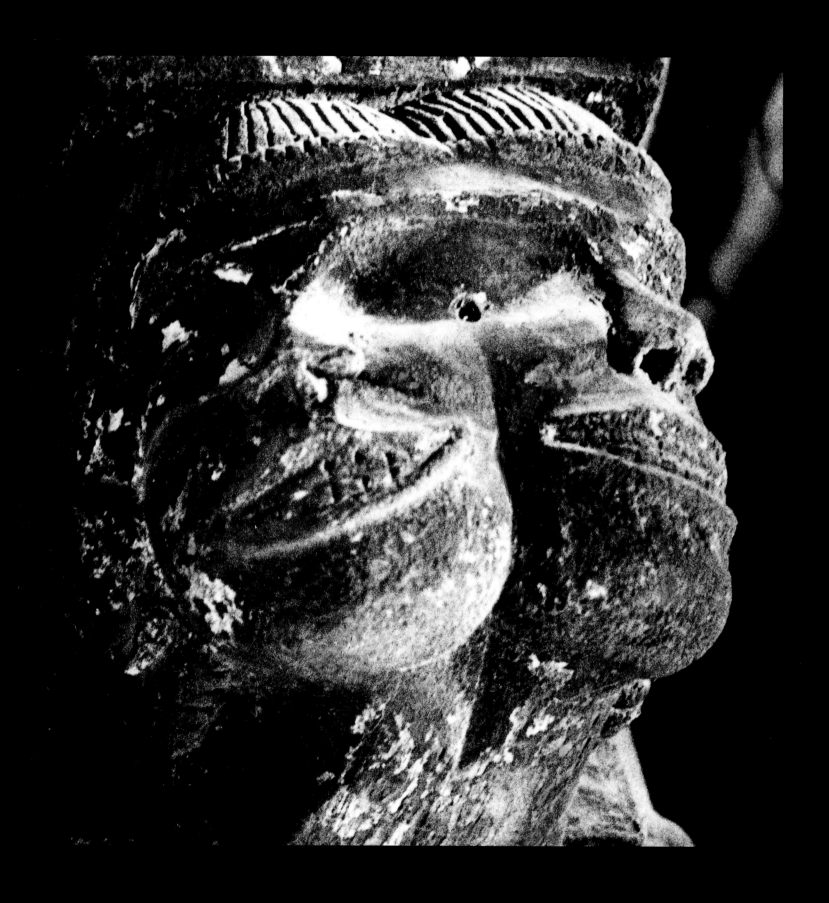

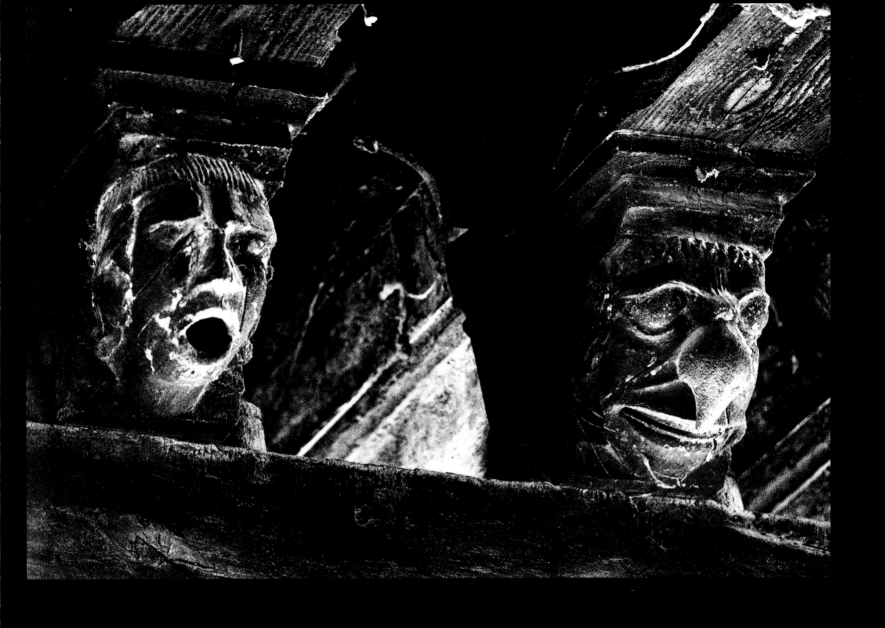

The siege was to last ten months before, on 1 March 1244, Pierre-Roger de Mirepoix left the castle under a flag of truce to negotiate terms of surrender. It was agreed that all the fighting men would go free, but that the Cathars had two weeks to denounce their heresy, or be burnt alive. During the following days, some of the soldiers embraced the Cathar faith; then, on the morning of 16 March, all the occupants of the fortress slowly walked down from the castle and 216 Cathars willingly submitted themselves to the vast funeral pyre. The site below the castle is known today as the Field of the Burned, and marked by a cross. It is said that this spot is surrounded by a particular force or energy, and that a strange white mist has been seen to rise from the ground and drift upwards towards the castle.

One of the many mysteries that surround the Cathars is the whereabouts and nature of the treasure that they are known to have smuggled out of Montségur Château before it fell. It is said to have been beyond material wealth, but has never been found. It was originally supposed to have been hidden in a fortified cave in the surrounding mountains, but only human bones and

skulls were discovered there. Others say that it was taken to sympathizers in a mountain village, where it is still concealed. The extraordinary events that took place in the nearby village of Rennes-le-Château, and the actions of its eccentric priest (see pages 158–163) are thought to bear out the notion that some kind of treasure was taken here, but nothing has yet been proved. There are also many theories as to the exact nature of this treasure. One describes it as a book or document that reveals the secret surrounding Christ's death and reincarnation; another that it was the legendary Holy Grail. If so, could it have a link to the Templar treasure? This would explain why so many Templars supported the Cathar cause.

Richard Wagner (1813–1883) is said to have visited Montségur Castle when he was writing his opera *Parsifal*, based on the Grail legend; and in the 1930s the Nazis, who perversely believed that they were the rightful inheritors of the Grail, sent a young researcher, a medievalist named Otto Rahn, to Montségur to search for it. He made two lengthy trips, but after the second committed suicide, taking to the grave any secrets that he might have discovered.

above
The Cathars of Montségur were burned alive as heretics, from a sketch by Émile Bayard, c. 1880

facing page
Montségur Château

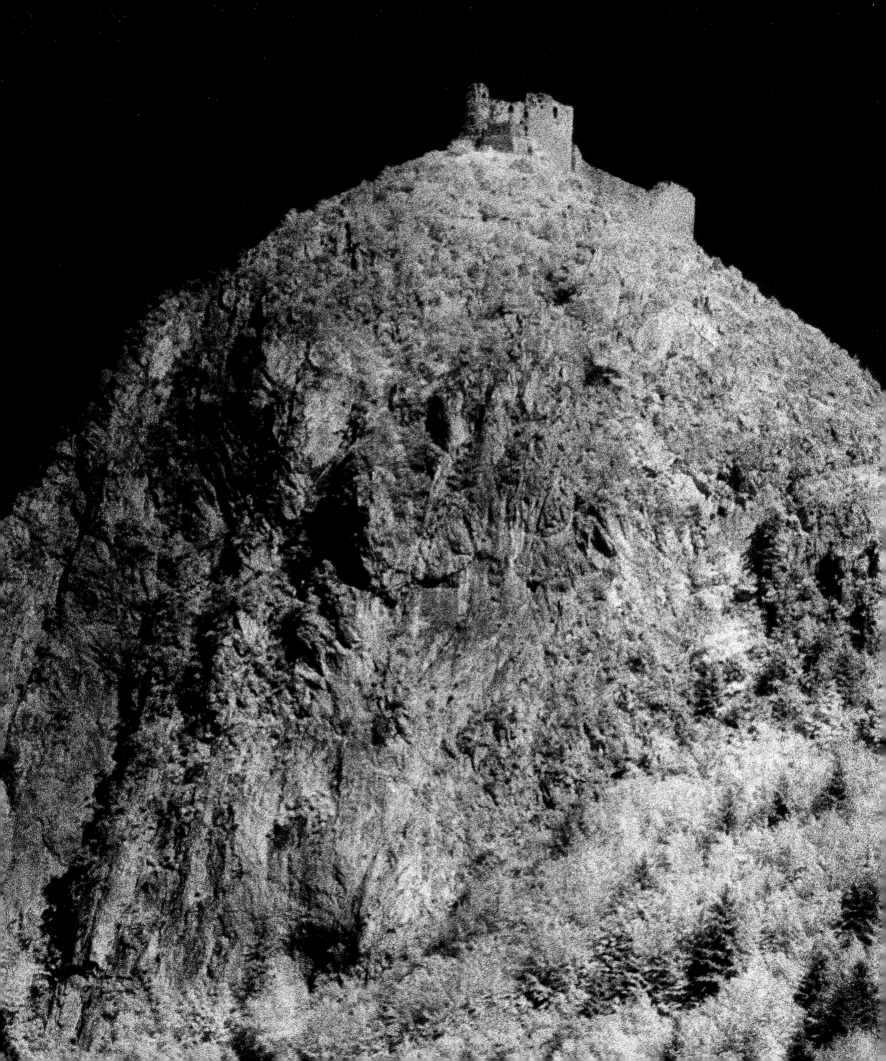

Lair of the Vampires
- 9 November -

If there is in the world one attested story it is that of the Vampires. Nothing is missing: procès-verbaux,
certificates from Notabilities, Surgeons, Priests, Magistrates. The juridical proof is most complete. With all this,
who believes in Vampires? Shall we all be damned for not having believed?

– Jean-Jacques Rousseau, Letter to Christophe de Beaumont, Archbishop of Paris, 1763

A wealth of archaeological excavations testifies to the importance in ancient times of the small town of Mazan in the mountainous region of the Vaucluse. It is also famous as one of the seats of the de Sade family. The most notorious of that bloodline was the Marquis Donatien Alphonse Françoise de Sade (1740–1814), the infamous erotic author and libertine who lived near Mazan, in the Château LaCoste. It was because of the many indecent, cruel acts of this multiple rapist and torturer that the term 'sadism' was coined.

A ring of stone sarcophagi dating from the sixth and seventh centuries circles the town's cemetery. These arcane coffins were discovered in the eighteenth century, hidden in the surrounding fields. Legend says that the local people had always lived in fear of vampire-like creatures that would assume the form of wolves in order to drink the blood of the newly dead. In those days scavenging wolves frequently came down from the hills as darkness fell, but the lids of these sarcophagi were made of heavy stone to prevent any such interference. The fact that they were often penetrated led to the enduring belief that only the supernatural powers of vampires could be responsible for such horrific crimes.

I climbed the small hill to the cemetery in the early evening. Like most graveyards, it has a very peaceful atmosphere, although the lines of sarcophagi on top of the walls give it an almost fortified appearance. Why, I wondered, should this legend have evolved here and nowhere else in Provence? Could such a quiet, picturesque town really be the lair of a colony of vampires that had cheated death by feasting on the blood of their unsuspecting neighbours? The church bell started to toll as I took the last of my photographs, and as I began my descent back towards the town square, I remembered that I had still to visit the de Sade Château.

facing page
Mazan Cemetery

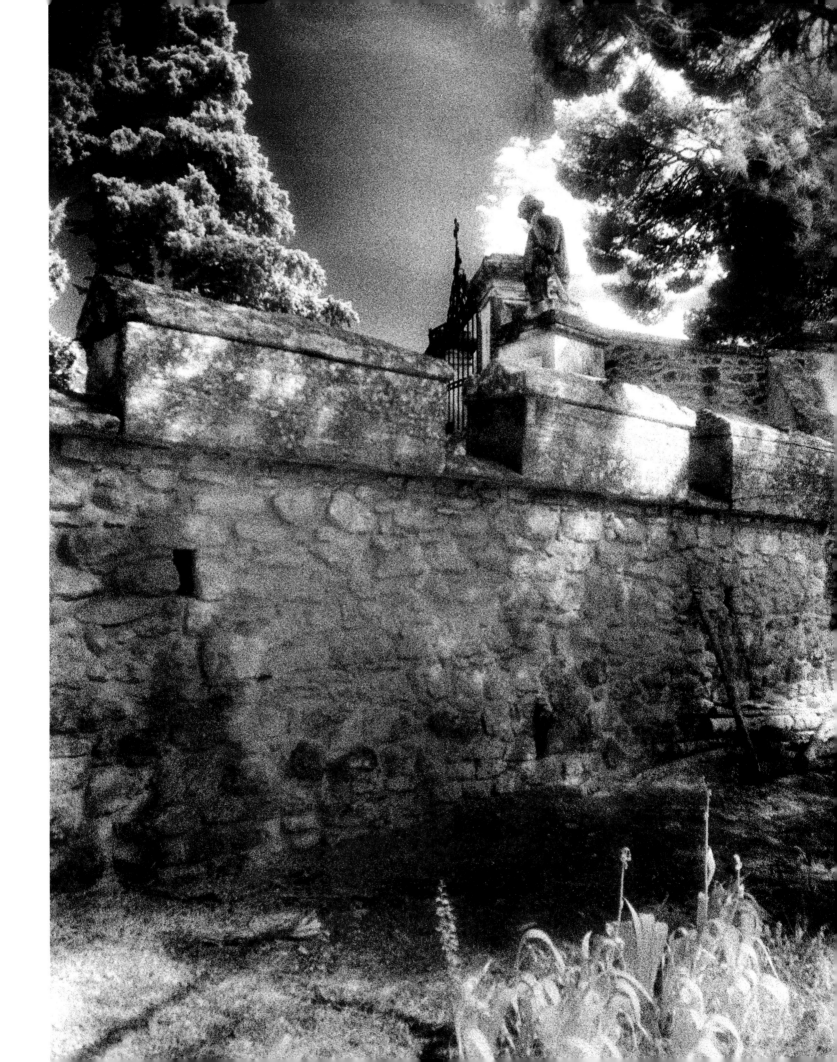

Legend of the Tarasque

- 10 November -

Rising beside the Rhône River, as if growing from the very rock it stands on, and separated from the town by a wide moat, Tarascon is one of the best-preserved châteaux in all of France. It protected the territory of the counts of Provence; it was one of their number, Louis II of Anjou (1377–1417), who began the building in 1400. It was eventually completed some fifty years later by 'Good' King René (1409–1480), a painter, writer and dramatist, who considered it the jewel in his dominion.

Today, with its steep, high ramparts, Tarascon looks more like a fortress than a palace. Unfriendly and threatening, the high, battlemented walls, with their few heavily cross-barred windows and projecting machicolations, gaze ominously down on the town and river, giving no hint of the elegance and comfort which was once displayed within. It was transformed into a military prison in the seventeenth century and later bore witness to the horrors of the Revolution. Desolation and terror were everywhere, and the fortress became the scene of political massacres. In 1794, many of Robespierre's compatriots were thrown from the castle's ramparts to their death below. This may explain the terrifying and inexplicable screams and groans that have been heard in the vicinity of the moat by unsuspecting passersby.

In his book, *The Golden Legend*, written in about 1255, Jacobus de Voragine

describes the creature known as the Tarasque, who lived in the river beneath King René's château: 'There was at that time…a dragon, half animal, half fish, wider than an ox, longer than a horse, with teeth like swords, the size of horns, which bore a shield on either side.' This horrific monster is said to have emerged from the water to drown his prey before devouring them.

In numerous descriptions of the beast certain particularities are recurrent; the length of the body, the enormous head with its fearful mouth, the spiny skin, the short legs and long tail. These all suggest that the creature was possibly a crocodile that had somehow made its way up the Rhône and felt at home in the marshy delta. The fact that it was foreign to the area would also explain why it was so badly represented in illustrations and pictures of the time. Provençal Christian tradition recounts that Saint Martha finally tamed the monster. She handed it over to the town's populace, who proceeded to tear this ravening symbol of paganism to pieces, before converting to the new religion.

Whether haunted by the legend of a mythical monster, or the cries of murdered men, I found the castle had a disturbing aura, even in the midday light. It was as if its dark secrets were seeping through the château's sun-scorched walls like pus from an open wound.

above

The Tarasque, sculpture by Pascal Demaumont, Tarascon

facing page

Tarascon Château

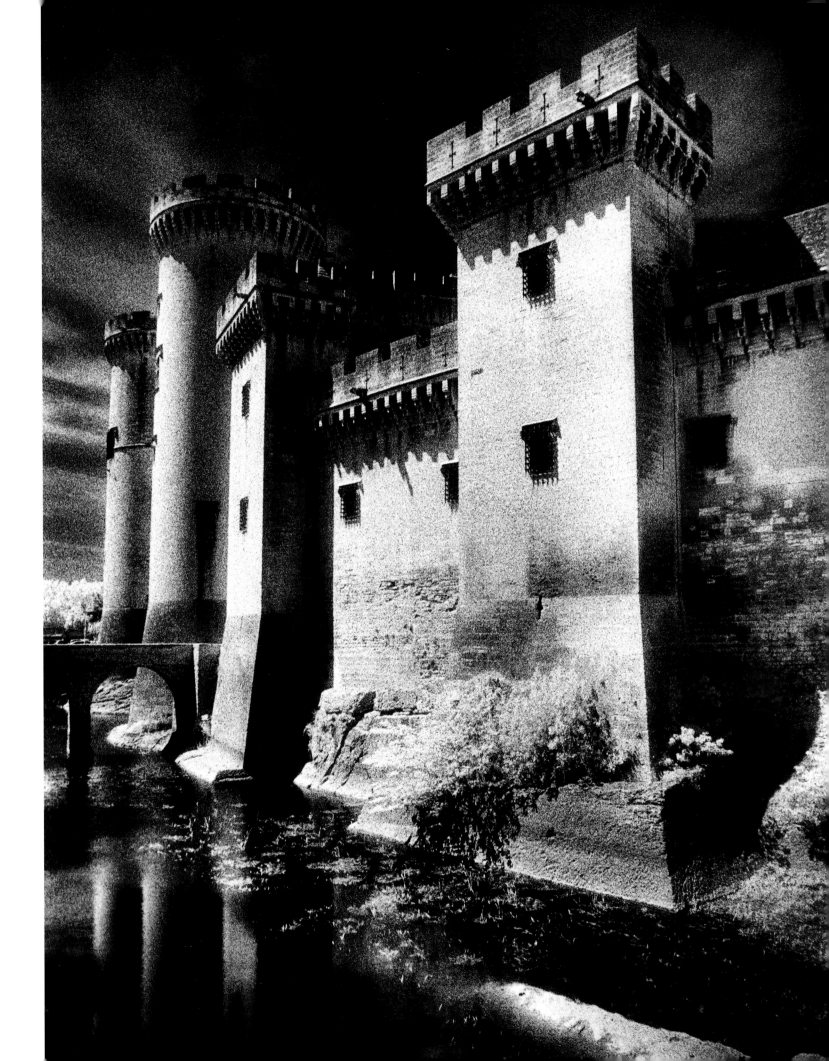

PROVENCE — MONTMAJOUR ABBEY
Island of the Dead
- 11 November -

In the fading light, the stark windows and sun-bleached walls of Montmajour give off a ghostly aura, and I could see why the monastery had held such a fascination for the painter Vincent Van Gogh (1853–1890), who drew inspiration from the architectural ruins and the surrounding landscape. As he wrote on 3 July 1888: 'I am just back from a day at Montmajour and my friend the sublieutenant accompanied me. Together, we explored the old garden and stole some excellent figs. Had it been larger, it would have called to mind Zola's Paradour: tall reeds, vines, ivy, fig trees, olives, pomegranate bushes with their bright orange flowers, age-old cypresses, ash and willow trees, oaks. Crumbling staircases, ruined pointed windows, blocks of white lichen-covered stone and tumbledown sections of walls scattered here and there in the greenery.'

Dedicated to Saint Pierre, the abbey was founded in 948 C.E. by Benedictine monks. It stands on a rock emerging from the marshes known as Mont Majour (Large Mountain). This had been a sacred site since the dawn of time; the island could only be reached by boat before the monks were sent to drain the surrounding marshlands. Here they discovered many tombs around the abbey, which had been dug into the blue rock-like basins. A stone support lay beneath the neck of each corpse. The foot of the donjon of the chapel at Saint-Pierre is also troglodyte, hewn out of the rock. One narrow passage leads to the hermitage, which is reputed to have been the confessional of Saint Trophime, founder of the nearby church in Arles (see pages 182–187).

The Chapelle Sainte-Croix stands outside the abbey walls and dates from the twelfth century. In the heart of the rock cemetery, the building is connected to the abbey by a long passageway. The shape of the chapel is most unusual in that it resembles a quatrefoil. This was allegedly chosen so that the chapel could contain a part of the True Cross, which the monks were said to possess. Pilgrims from all over Europe came to Montmajour to partake in the 'Holy Cross Pardon', and this became a considerable source of income for the abbey. I found this part of the rock cemetery very unnerving; the temperature seemed unnaturally cold and the atmosphere overwhelmingly sad.

At the end of the Hundred Years' War, the monastery was fortified; it later took on a new lease of life in the early part of the seventeenth century when it was re-formed by the congregation of Saint-Maur, who believed in the strict observance of the Rule of Saint Benedict. But their approach was not popular with all the monks, and the monastery they added appeared more like a palace than a place of worship. In 1786 the abbot, Cardinal Rohan-Guémenée, who was involved in a scandal at Louis XVI's court, was deposed. The king then dissolved the abbey, which by now numbered only eleven monks. During the Revolution it was declared national property and sold, its new owners stripping it of its wall panelling, doors and beams. The strange sculpted figures in the twelfth-century cloisters remain, however: their singular features are symbolic of a lost world, an old religion, hidden beneath the veil of Christianity.

facing page
Chapelle Sainte-Croix, Montmajour Abbey

pages 180–181
Sculpted heads, the cloisters, Montmajour Abbey

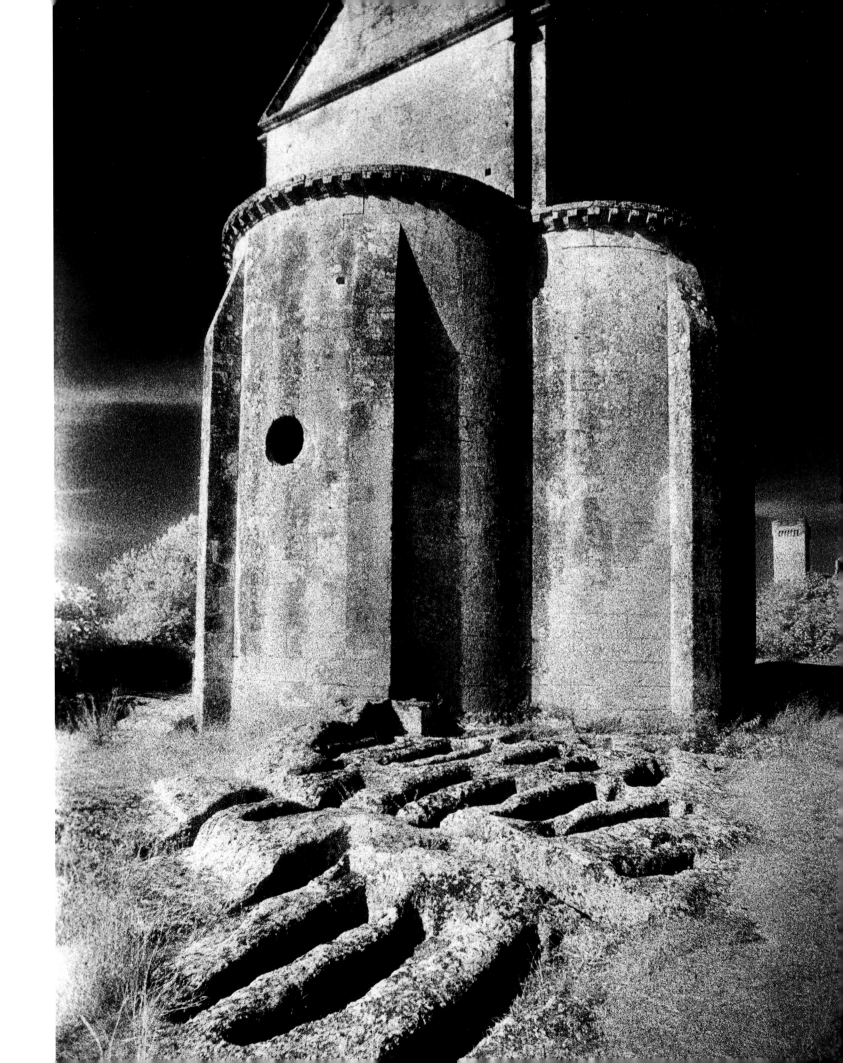

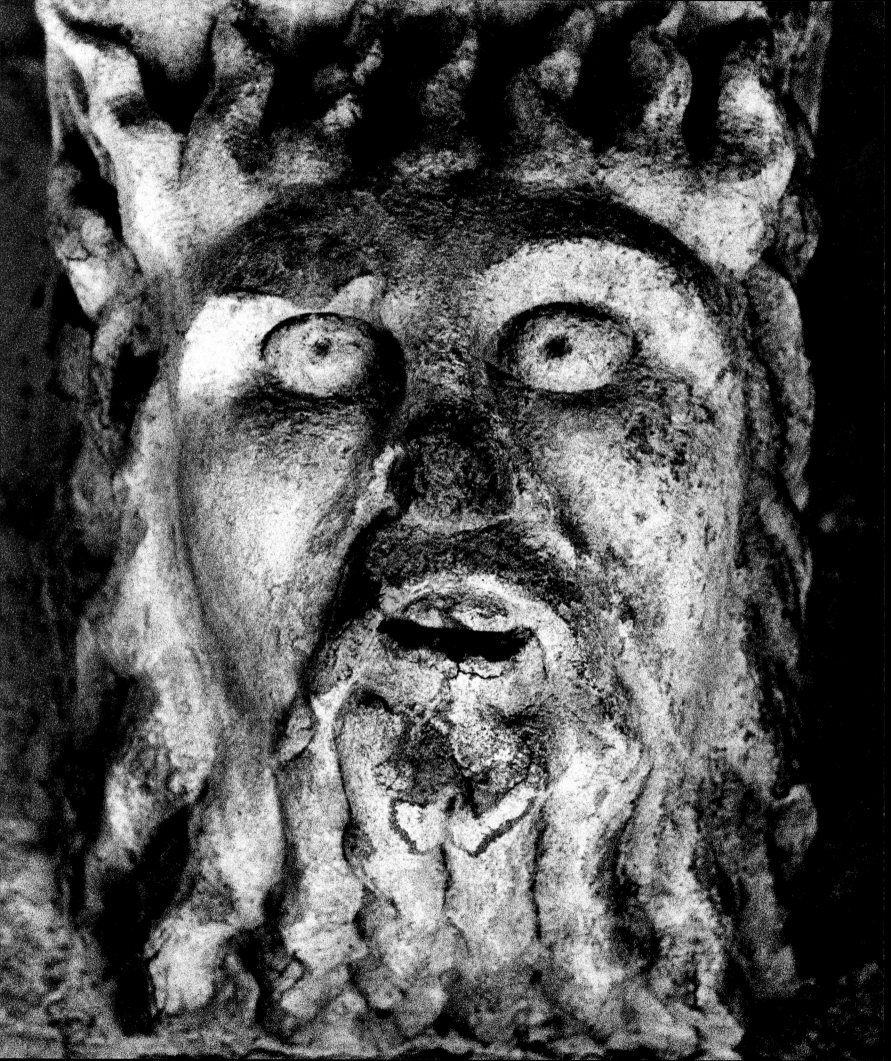

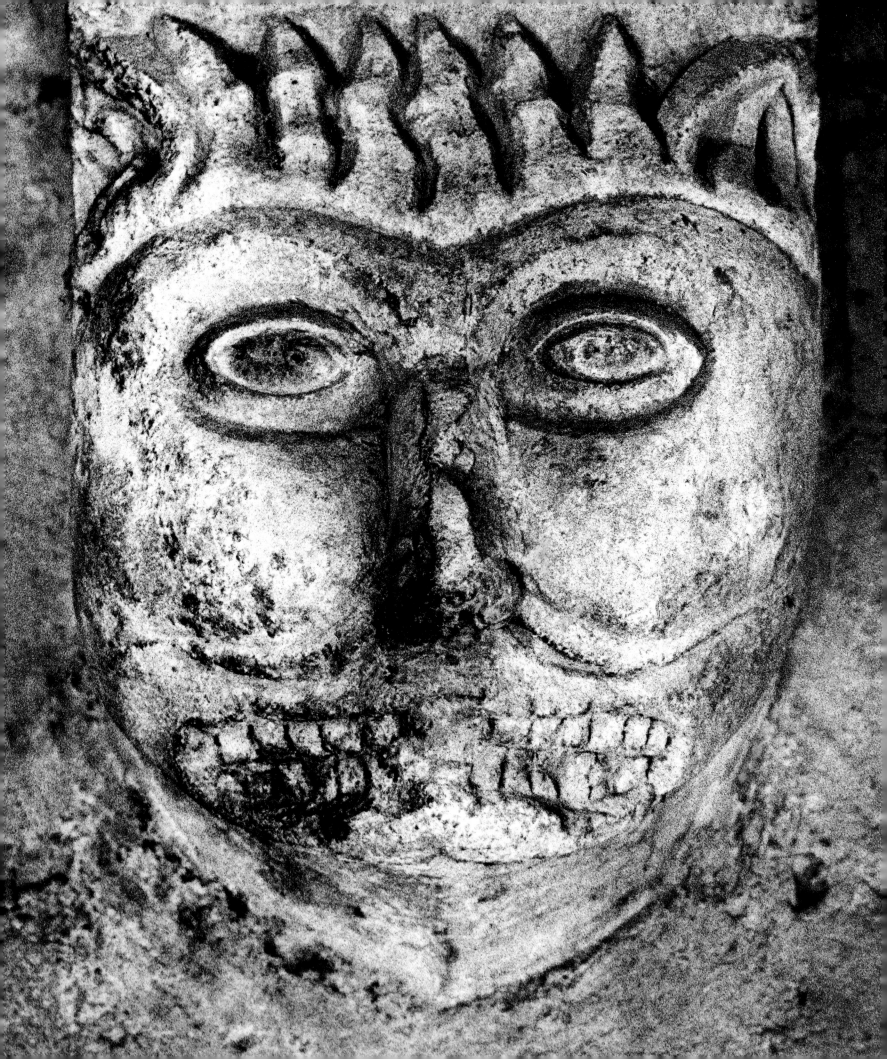

City of Haunting Dreams
- 12–13 November -

I first visited Arles in the 1980s when I was invited to exhibit my work at the international photography festival. Arriving by train in the early evening, I was struck by the image of the magnificent lions above the ancient city gates and felt the presence of powerful spirits from the past. On the opening night of the exhibition there was a banquet in the Roman amphitheatre. Walking into the centre of this vast arena where so many gladiators had fought and died in grotesque trials of strength was an extraordinary experience; it was at the same time humbling and unsettling to imagine their fate. The party went on until the early hours as we ate roasted oxen, wild fruits and drank fine wine, but I remembered feeling uneasy, as if other eyes were watching me. However, I was young, and although I sensed the past all around me, I was living very much for the present. At the end of the week my photographs were shown at midnight in the Roman theatre, projected onto a massive screen that was surrounded by crumbling columns. It was the perfect setting for my images of Gothic ruins and bizarre follies. That week in Arles seemed more like a dream than a reality; I vowed to return in quieter times to discover why I felt so attracted—yet at the same time disturbed—by this haunting city.

Now, as I pass the lion gates once more, I am reminded how both the Greeks and the Gauls may have left their mark on this ancient city, but it was the Romans who came to conquer and who have left indelible traces. Their ruins are vast and the theme is always the same: the immensity of Roman power; the absolute subjugation of tribes or nations that have been annihilated or reduced to slavery.

So it is with the vast amphitheatre in Arles. Most ruins have an aura of romance, but here there is only the cruelty of death. As I stand again at the centre of the arena, I imagine how it must have felt to be a gladiator. The enormity of it as twenty thousand voices bayed for your blood, and the horror as one fought to stay alive, only to die another day. It must have seemed like an immense prison with no escape. Everything about its shape, its height, the empty eyes of the arched windows, and especially the dark corridors below the outer walls, remains intimidating. As I wander through the circular passageways, between the cells where the gladiators awaited their fate, I can sense the restless spirits of the unfortunate men who are said to haunt this part of the amphitheatre. I was told that only recently an elderly man, a tourist, had been terrified by someone who passed in front of him in one of these tunnels. He described a tall figure wearing a long brown cloak and having a face the 'colour of death'.

In the Middle Ages, the arena was turned into a fortress: fortified watchtowers were added to the outer walls of the amphitheatre, and houses and churches built inside. This miniature city was demolished in the early part of the nineteenth century. By now the overwhelming melancholy of the darkness and the dust of ages is beginning to make my flesh creep. I long for the light of day.

To the east of the city is the huge necropolis of Les Alyscamps. The name comes from the Latin, *Elyssii campi*, meaning Elysian fields, which in both Greek and Roman mythology was the name of the avenue leading heroes to the kingdom of the dead, a paradise reputed to lie at the end of the world. This singular landscape of ancient sarcophagi dates back to pagan times and is the source of many legends. During its reputed consecration by Saint Trophime, Christ

facing page
Figures in the entrance to Saint-Trophime Church

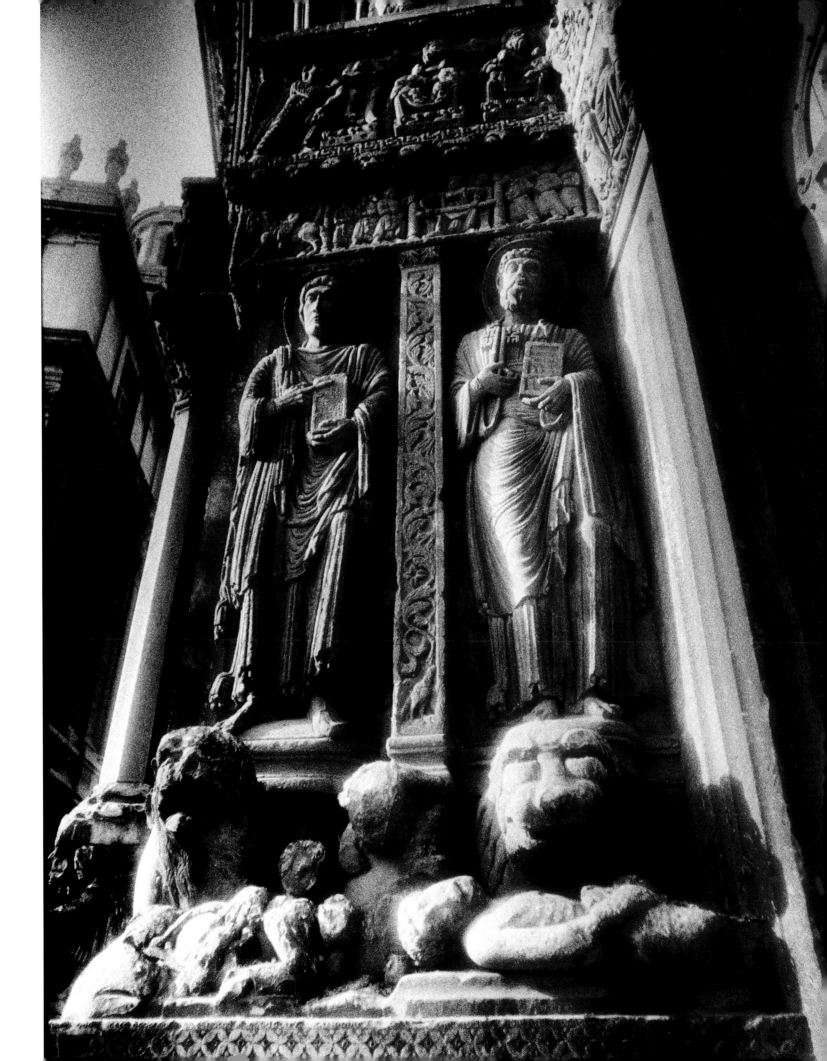